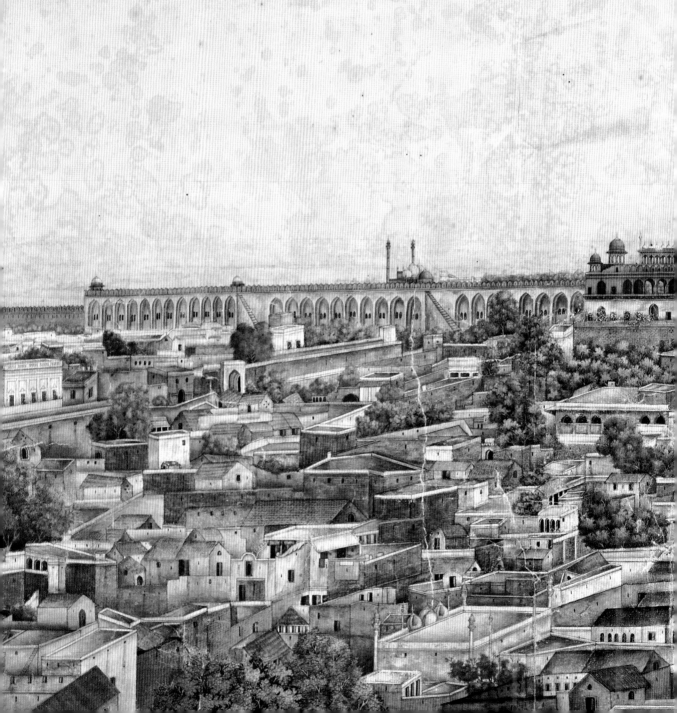

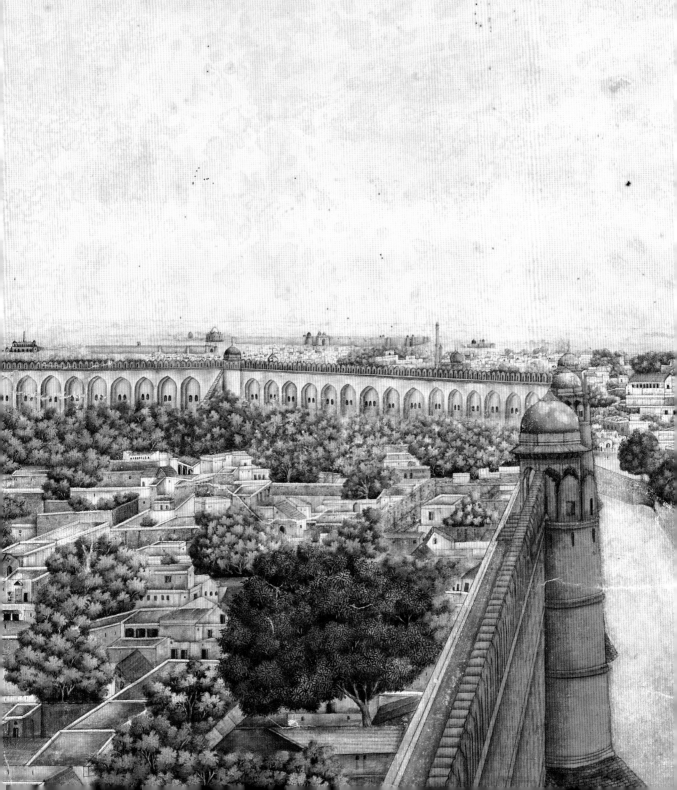

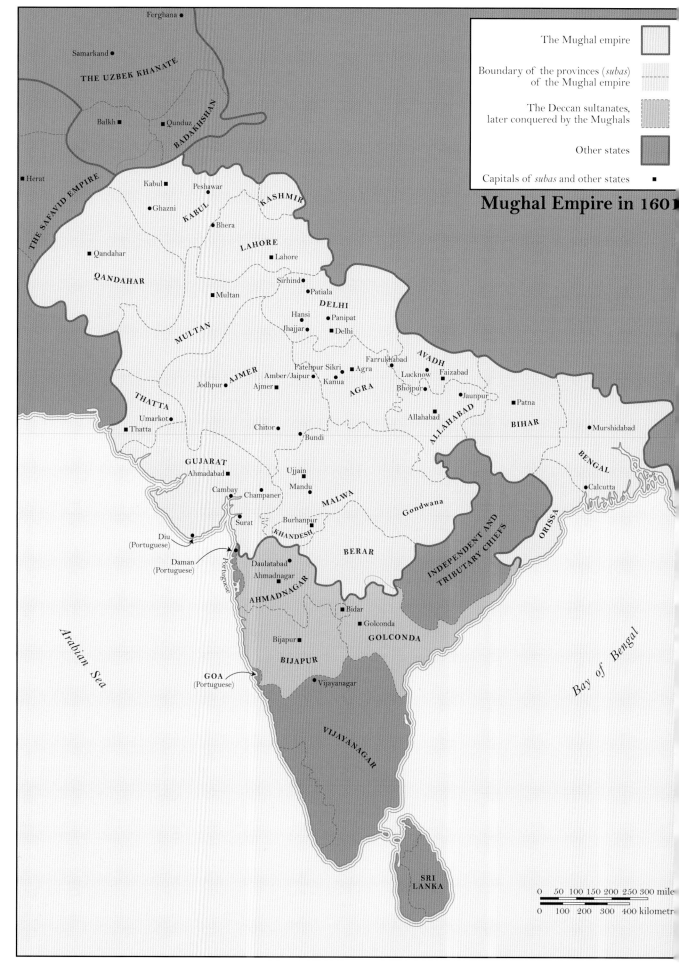

Ferghana •

• Samarkand

THE UZBEK KHANATE

Balkh ■ ■ Qunduz

BADAKHSHAN

■ Herat

THE SAFAVID EMPIRE

Kabul ■ Peshawar •

• Ghazni KABUL • Bhera

KASHMIR

LAHORE

■ Qandahar • Lahore

QANDAHAR Sirhind •

Multan • • Patiala

MULTAN Hansi • • Panipat **DELHI**

Jhajjar • ■ Delhi

Fatehpur Sikri Farrukhabad • **AVADH**

Jodhpur • AJMER Amber/Jaipur • ■ Agra Lucknow ■ • Faizabad

THATTA Ajmer ■ Kanua AGRA Bhojpur •

Umarkot • Chitor • Allahabad • Jaunpur ■ Patna

■ Thatta • Bundi ALLAHABAD **BIHAR** • Murshidabad

GUJARAT BENGAL

Ahmadabad ■ Ujjain • • Calcutta

Cambay • • Champaner Mandu • MALWA Gondwana ORISSA

Surat • Burhanpur • BERAR

Diu KHANDESH INDEPENDENT AND TRIBUTARY CHIEFS

(Portuguese)

Daman
(Portuguese) Daulatabad •

Ahmadnagar •

AHMADNAGAR • Bidar

■ Golconda

Bijapur ■ GOLCONDA

GOA BIJAPUR

(Portuguese) • Vijayanagar

*Arabian
Sea*

VIJAYANAGAR *Bay of Bengal*

SRI
LANKA

The Mughal empire

Boundary of the provinces (subas)
of the Mughal empire

The Deccan sultanates,
later conquered by the Mughals

Other states

Capitals of subas and other states ■

Mughal Empire in 160[1]

0 50 100 150 200 250 300 mile

0 100 200 300 400 kilometre

The Lives of
the Mughal Emperors

John Reeve

BRITISH LIBRARY

Notes to the reader

This book is illustrated almost entirely from the British Library's collections, including those from the old India Office and its predecessor the East India Company. Where appropriate the captions give the date of the event depicted, followed by the date of the painting and the name of the artist, if known. The bibliography includes key sources, many of which can be accessed online.

Use of the term 'India' refers to the Indian subcontinent and includes areas that we now know as Pakistan and Bangladesh.

The key Mughal emperors

Babur	1526–30
Humayun	1530–40; 1555–56
Akbar	1556–1605
Jahangir	1605–27
Shah Jahan	1627–58
Aurangzeb	1658–1707
Bahadur Shah I	1707–12
Jahandar Shah	1712–13
Farrukhsiyar	1713–19
Muhammad Shah	1719–48
Ahmad Shah	1748–54
Alamgir II	1754–59
Shah Alam II	1759–1806
Akbar II	1806–37
Bahadur Shah II	1837–58

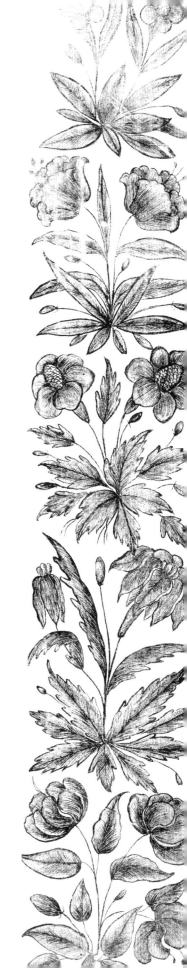

Introduction

The Mughal dynasty ruled much of the Indian subcontinent for 300 years, from the early sixteenth to the mid-nineteenth century (1526–1858). It was one of the three major Islamic royal houses of the period, together with the Safavids in Persia (1501–1736) and the Ottomans in Turkey (1299–1922). The Mughals were not native to India – their name derives from the Persian word for Mongols and their roots are in central Asia. The Mughal dynasty referred to themselves as the House of Timur, the 'Timurids'. Babur, the first Mughal emperor of India, was proud of his descent from both Timur the Lame (Tamburlaine) and Genghis Khan. Timur (1336–1405) had ruled over Iran, Afghanistan and Central Asia, Anatolia and the Caucasus as well as much of what are now Pakistan and Iraq. His descendant Babur ruled in Samarkand and Kabul before successfully invading Hindustan in 1526 and so beginning the period of Mughal rule over India, along with parts of what is now Afghanistan. Babur was not the first Islamic conqueror of an ancient Hindu country; Islam had already arrived in India as early as the eighth century. Babur was supplanting an earlier Muslim dynasty, the Lodi sultans of Delhi, who had ruled since 1451 (and whose tombs survive in the Lodi Gardens in New Delhi).

The illustrations to the right and overleaf depict homage from later Mughals to their ancestor Timur. The first illustration dates from the end of Akbar's reign and shows musicians celebrating the birth of Timur with a raucous fanfare, just as they later announced events from above Drum House of the Red Fort in Delhi. Food, drink and a cradle are being brought into the women's quarters where Timur is being tended by wet-nurses, while outside astrologers predict his future. The second (from the reign of Jahangir) shows Timur enthroned with his descendants Babur, Humayun, Akbar and Jahangir to left and right.

As with all dynasties, not all Mughal emperors were equally competent or lucky. There were recurring problems of succession that frequently resulted in a bloodbath. Alcohol and drugs such as opium were constant temptations for many members of the Mughal dynasty, and there was always the danger of enjoying court life and the harem too much and neglecting state affairs, as was the case with Shah Jahan in later life, and also most emperors who succeeded his son, Aurangzeb. But despite all this, Mughal emperors (with a few notable exceptions) were cultivated patrons of the arts; some were even poets themselves.

Celebrations at the birth of Timur, from the *Akbarnama*, c.1602–03. Sur Das Gujarati, Or.12988, f.34b

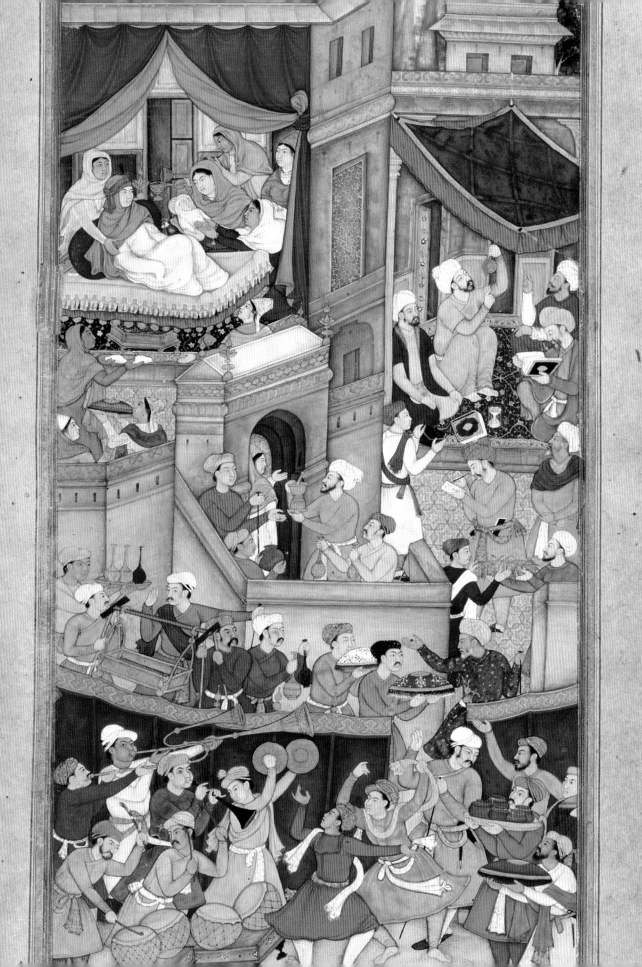

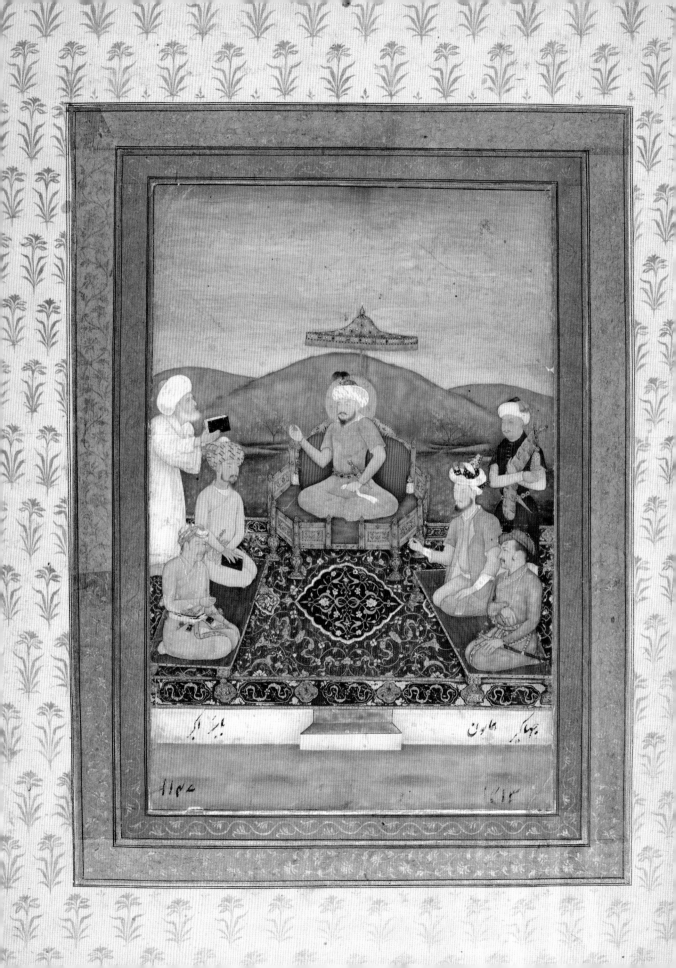

It required constant vigilance for the Mughal emperors to maintain power successfully, facing as they did many external threats. They were Muslim outsiders ruling (directly or indirectly) a predominantly Hindu country which included numerous other minorities such as Jains, Sikhs, Parsees and Christians. There were many other native dynasties still in power who often challenged the emperor's authority, in addition to ambitious neighbours looking for any signs of weakness. When considered from this perspective, the three centuries of Mughal rule are remarkable.

The Mughal dynasty got off to a very shaky start under the first two emperors, Babur and Humayun. Babur briefly took control of part of north India, but his son Humayun was unable to consolidate these gains and went into a long exile from which he only briefly returned. Their successors for the next century-and-a-half had more success, and under the four major emperors, Akbar, Jahangir, Shah Jahan and Aurangzeb, the Mughal Empire expanded greatly. By the end of Aurangzeb's reign in 1707 the Mughals claimed power over nearly the whole subcontinent. They ruled over 150 million people,

perhaps a quarter of the world's population, through an increasingly complex web of alliances, marriages and warfare. Only the southernmost tip of India eluded the Mughals, plus permitted European enclaves in Goa (Portuguese), Bombay, Madras and Calcutta (British). At various times the Dutch, Danes and French also had Indian bases. As a result of these contacts the splendour of the 'Great Mogul' became well known in Europe, through accounts by Jesuits such as the Portuguese Father Antonio Monserrate, ambassadors like Sir Thomas Roe and other travellers, for example the French jeweller Jean-Baptiste Tavernier and the French doctor François Bernier, Aurangzeb's physician for eight years. European adventurers and later empire-builders were attracted by India's wealth and natural resources, just as Babur and previous invaders had been.

After Aurangzeb's long reign, and in particular his Herculean efforts to conquer the south of India, the Mughals subsided into a more precarious and finally largely ceremonial role. In the five decades after Aurangzeb's death there were six emperors, of whom three were murdered and one deposed. Eventually

Timur and the early Mughals: Babur, Humayun, Akbar and Jahangir, c.1620.
Hashim, Johnson Album 64, 38

Overleaf: Detail from a panorama showing the procession of the Emperor Bahadur Shah II to celebrate the feast of Id, 1843 (see 32). Add.Or.5475, f. 59v-D

even the ceremonial role of the Mughals, whose 'empire' had been reduced to little more than the Red Fort in Delhi, was finally snatched away by the shaken and vindictive British in 1858 following the Indian Rebellion.

Although this is a book mainly about men, it also features some remarkable women who played a crucial role in Mughal fortunes. These include queens such as Jahangir's Nur Jahan, Mumtaz Mahal in whose honour Shah Jahan created the Taj Mahal, and Zinat Mahal who joined the last emperor in exile. There were also loyal sisters, daughters and aunts including Gulbadan, Akbar's aunt who wrote at his behest an account of the reign of Humayun, and Shah Jahan's cultivated daughter Jahanara Begum who cared for him during his imprisonment. Much of the intrigue at court revolved around the harem or zenana, with its rival queens and foster-mothers who nursed Mughal heirs and to whose sons, imperial foster-brothers, Akbar said he was joined by a river of milk.

What image do we have today of this extraordinary dynasty? The Mughals were highly conscious of their legacy, commissioning histories and writing memoirs, although Aurangzeb insisted that 'No story of my life should be told to anyone'. The Mughal legacy in architecture is a familiar part of India's image today, most notably the Taj Mahal which was built between 1632 and 1653. But the serenity, purity and permanence of this extraordinary building should not deceive us: its builder Shah Jahan spent his last years imprisoned by his own son Aurangzeb, able only to glimpse his masterpiece from his window.

The record of the Mughal era is now widely dispersed, as a result of subsequent Persian and Afghan raids

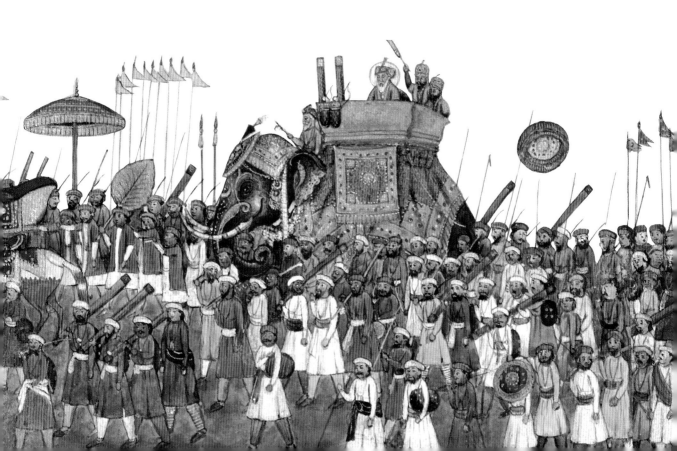

and the British conquest of India. While we can still admire the exquisite gardens that the Mughals introduced to India, the jewels and the textiles, the poetry and prose, the lavish images of court durbars, the beautifully painted flowers, birds and beasts, and records of people and events, there are gaps. There is no Mughal equivalent of Versailles for us to visit, no Royal Library as at Windsor, no portrait galleries or furnished throne rooms. So much has been looted or destroyed. We have to imagine how the Red Fort in Delhi, Agra Fort or Fatehpur Sikri once were, before conquest ripped out their heart, or neglect ensured their decline.

It is for the richness of their culture that the Mughals are most remembered. It was a fusion of Central Asia, Persia and the India that they conquered. Humayun's exile in Persia and interest in Persian art prompted a new art form, the so-called Mughal miniature. The Mughals and their Muslim predecessors in India brought Persian art, language, etiquette and cuisine to India. There are no contemporary statues of Mughal emperors, but there are many portraits, some highly allegorical and stylised but others clearly reflecting the personalities of the emperors: thus we have depictions of the aged Akbar and Aurangzeb, the splendidly bejewelled Shah Jahan and Jahangir, and the troubled later rulers. Commemoration of individual emperors has also many other forms: Babur is a national hero in Uzbekistan and Kyrgyzstan, and remembered also in Afghanistan where he is buried. Akbar appeared on *Time* magazine's list of the 25 top world leaders in history, singled out for his belief in tolerance. The Mughal era, it would seem, continues to inspire.

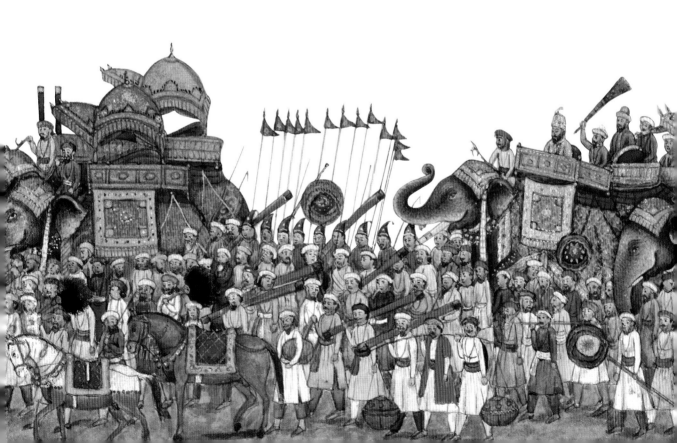

1 Babur Conquers Hindustan

'In the province of Ferghana, in the year 1494,
when I was 12 years old, I became king.'

So begins the *Baburnama*, Babur's account of his life and foundation of the Mughal empire, and one of the first Islamic autobiographies. Babur's father had died unexpectedly while feeding his pigeons in a castle dovecote that collapsed into the ravine below. 'Umar Shaikh Mirza flew, with his pigeons and their house, and became a falcon', as his son poetically put it.

Ferghana (northeast of Samarkand in modern Uzbekistan) had long been famous for its horses. As a small kingdom it was not enough for the ambitious Babur, who was only 15 when he went on to conquer Samarkand, formerly the capital of his ancestor Timur and located on the Silk Road. After losing Ferghana and Samarkand to other members of his family in the perpetual shift of fortunes, Babur took Kabul in 1504 and made it his capital. As if it weren't enough to elude his enemies and hold on to the power he had, Babur dreamed of invading and conquering India. In this he was spurred on by the example of his ancestor Timur, who had raided Delhi in 1398: '[my] desire for Hindustan had been constant, but … a move on Hindustan had not been practicable and its territories had remained unsubdued. At length no such obstacles were left.'

He now had the forces and the opportunity to fulfil his ambition. In April 1526 he finally confronted the far larger armies of the Lodi sultan of Delhi near the village of Panipat, 90 km north of Delhi. He describes the fateful battle which saw the end of the Lodi dynasty's 75 years in power: 'I put my foot in the stirrup of resolution, set my hand on the rein of trust in God and moved forward against Sultan Ibrahim… When the incitement to battle had come, the Sun was spear high; till mid-day fighting had been in full force; noon passed, the foe was crushed in defeat, our friends rejoicing and gay. By God's mercy and kindness, this difficult affair was made easy for us! In one half day that armed mass was laid upon the earth.'

Babur's great advantage was artillery, which had been used frequently in sieges but never before on the battlefield. His two-dozen cannon so terrified the enemy elephants that they trampled their own troops. Babur was also a skilled tactician and had trained a disciplined force which stood to benefit from conquest, whereas the Lodi army relied on mercenaries.

Babur made his capital at Agra. But there was little time to enjoy court life: the war of conquest in northern India had only just begun. Babur went on to defeat the Hindu Rajput rulers in 1527, a victory marked by a great tower of skulls. One of the spoils of war was probably the famous diamond Koh-i-Noor ('Mountain of Light'), later to form part of the British crown jewels.

The battle of Panipat between the armies of Babur and Ibrahim Lodi (1526), from the *Baburnama*, c.1590–93. Deo Gujarati, Or.3714, f.368a

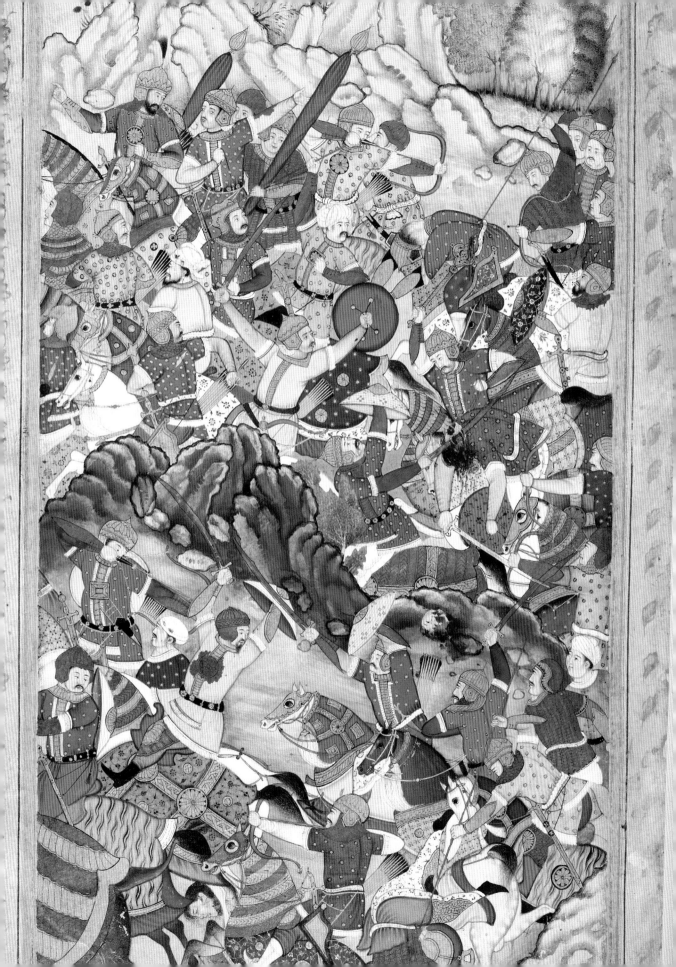

2 Babur's New Kingdom

'The chief excellency of Hindustan,' Babur wrote, 'is that it is a large country and has abundance of gold and silver. ... as far indeed as the great ocean the peoples are without break.'

After describing his victory at Panipat, Babur goes on to detail the country he was beginning to conquer. He describes with fascination the elephant and the rhinoceros, the warthog, the squirrel, the peacock and the talking parrots, and how bullocks drew water from wells. Almost 30 pages of Babur's memoirs are taken up describing fauna and flora: jasmine, hibiscus and oleander and the many uses of the coconut palm. The mango was for him the best of Indian fruits, though often not ripe enough. But after all this almost scientific detail come the criticisms. 'Hindustan is a country of few charms and the people do not have good looks.' He felt oppressed by heat, dust and wind. The people had 'no genius, no comprehension of mind, no politeness of manner, no kindness or fellow feeling, no ingenuity or mechanical invention …' There were no good breads, hot baths or decent melons. Like his men, Babur often pined for Kabul or Samarkand.

There are few monuments from Babur's brief reign. He describes his own building projects (of which little survives) and expresses admiration for Rajput buildings, such as the palace at Gwalior (south of Agra). It survives today, like so many Indian fortresses high up on massive sandstone rocks, and is decorated with coloured tiles and paintings of geese, crocodiles and peacocks. At nearby Urvah, Babur was disgusted by the naked Jain figures (shown here to the right, carved into the rock face), and ordered them to be destroyed. Fortunately, some parts survived, and modern sculptors have restored their faces. This image is from 60 years later, one of many illustrations to the *Baburnama* commissioned by later emperors, in this case from the artist Dhanraj.

Babur was a challenging role model for his successors – physically extremely strong and with a hearty appetite. He was famous for swimming rivers, lifting heavy men and a great admirer of wrestling. At one point he gave up drinking wine because he felt it was a sign of weakness, but then regretted it. He castigates himself in his memoirs for excessive taking of opium, although this seems to have been quite normal for people like him: drinking and drugs were to tempt most of his successors. Babur was also a sensitive poet, intoxicated by words, and curious about everything and everyone.

Babur at Urvah near Gwalior (1528), *c.*1590–93. Dhanraj, Or.3714, f.478a

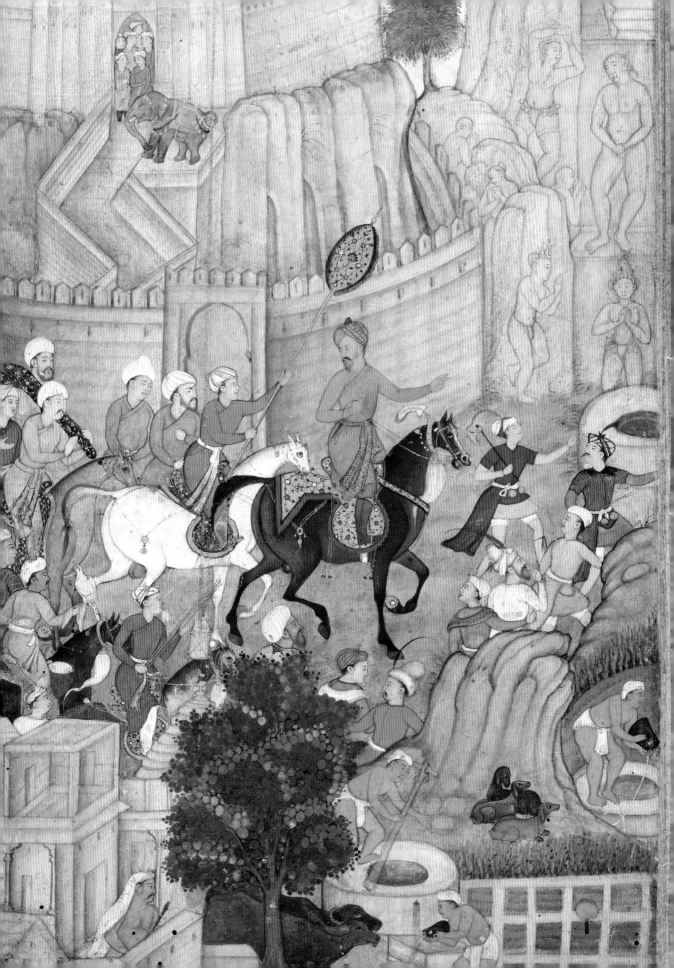

3 Babur and the Paradise Garden

One of the first things Babur did after winning the battle of Panipat was to create a formal garden of the kind he had known in Samarkand. He wanted to make 'that charmless and disorderly' India more like home with geometric and orderly gardens, on the *charbagh* (four quarters) plan. His first garden, the Aram Bagh outside Agra, follows the Persian model of Paradise through which waters flow. Pumped water supplied the channels; fountains, pavilions and tamarind trees supplied shade, and there were bathhouses nearby. Tents could be pitched there for special ceremonies, public audiences and banquets. Gardens became an essential part of every Mughal fort, palace and tomb – places of cool, calm and order in a hot and dusty climate and an uncertain world. Gardens were given poetic names, such as Light-scattering, Rose-scattering, Gold-scattering, Heart-expanding. Later, Akbar developed riverside gardens, and Shah Jahan created notable gardens at the Taj Mahal and a night garden in the Red Fort at Delhi with night-blooming jasmine.

Babur became king at a young age and died aged only 47, before he had securely established his dynasty. Subsequent events revealed how it was his skill and willpower that had enabled him to grasp power and keep it. In her account of his reign, Babur's daughter Gulbadan tells the extraordinary story of his death in 1530. His son Humayun had been taken seriously ill and appeared to be dying. Babur believed that a supreme sacrifice would need to be made – his own life. Having prayed, he walked three times round Humayun's bed and then announced: 'We have borne it away.' As Humayun grew stronger, Gulbadan tells us, Babur sickened and died.

Babur wanted to be buried in his beloved Kabul in the gardens he had created there with its plants imported from India. Nine years after his death he was finally laid to rest there.

Babur creates a garden at Istalif (1504), *c*.1590–93. Mahesh, Or.3714, f.180b

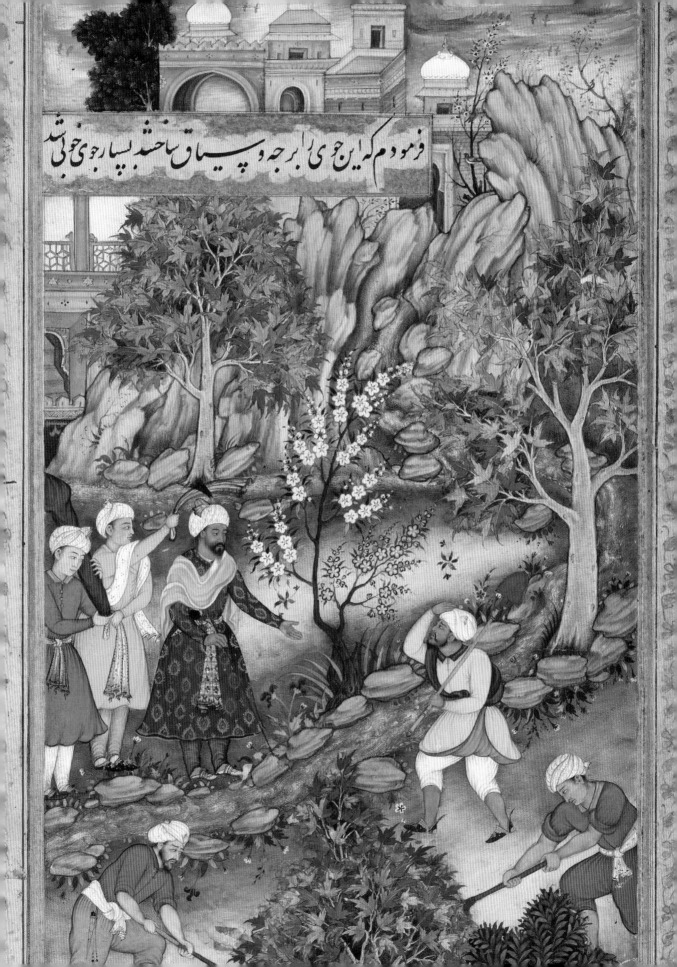

فرمودم كه اين جوى ابرجه و پسياق ساخته بسيار جوى خوابى شد

4 Humayun Inherits the Throne

In 1530 Humayun was 23 and had been groomed for power. Babur had kept a close eye on his development, admonishing him for his spelling and writing style, and criticising his impulsiveness. He left his son a difficult inheritance: by the time of Babur's death his empire was not yet secure and was encircled by enemies. Neither the army nor the administration was properly established and the treasury was almost empty. Humayun's half-brother Kamran was already ruling in Kabul and Lahore, and the rivalry between Babur's sons was to create instability. Babur had told Humayun, unrealistically, 'Do nothing against your brothers, even though they may deserve it.'

A lot depended on the character of the man on the throne. Humayun was cultivated and not inexperienced. Abul Fazl, author of the *Akbarnama*, said of Humayun: 'He was glorious for right-mindedness and lofty courage in every enterprise that he engaged in.' But he lacked his father's willpower, application and military genius, and after ten years in power was forced into exile for 15 years.

This lack of strong leadership was not apparent at the outset of Humayun's rule: he led his armies successfully against the Lodis at Lucknow and on to victory in Gujarat and Malwa. But then he rested and did not secure any of these gains. This indecisiveness only encouraged his enemies. Humayun settled at Agra where he wrote verse and indulged in drink, bhang, opium – and astrology. Each day Humayun wore robes in the colour of the planet associated with that day, for example black for Saturn on Saturday. Where the different groups of courtiers sat on a special carpet was also astrologically determined. Eulogies improbably describe the peace of his reign, where protected by his justice 'the deer sleep in the lap of panthers'. More accurately the panthers were massing and the deer were caught unawares. Humayun's nemesis was Sher Shah Sur, an extremely able Afghan, who had been one of the officers of the Lodi dynasty. In 1537, with an apparently weak emperor otherwise occupied, he seized his opportunity to take Bihar and from there to challenge the Mughal throne and to force Humayun into exile, ultimately in Persia.

Celebration of Humayun's birth at Kabul (1508), *c.*1590–93. Sur Gujarati, Or.3714, f.295a

طوی ولادت همایون شد امرا و غیر امرا خورد و کلان سلچق آوردند

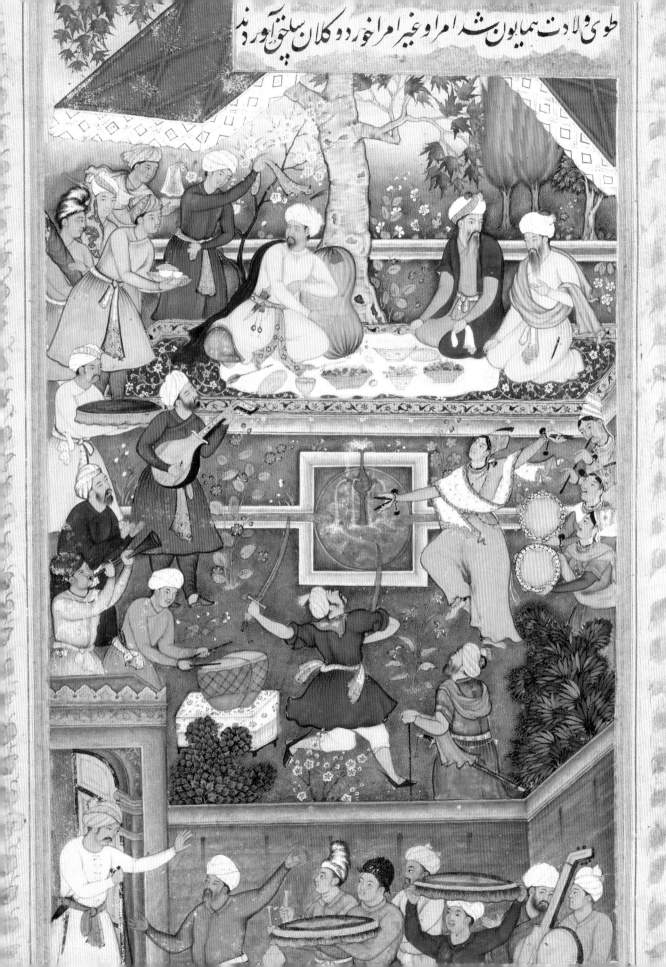

5 Humayun Loses His Kingdom

In his 'Reminiscences of Imperial Delhi' Sir Thomas Theophilus Metcalfe (1795–1853), the British representative at the last Mughal court, gathered images and historical records of a city and a dynasty that were about to collapse. Metcalfe's account shows his fascination with the Mughal epic and how it was developing as more stories were collected and retold. Here he describes some of Humayun's mishaps while fighting Sher Shah:

'In AD 1535/6, the Emperor Hoomaioon found it necessary to march in person to check if not subdue this ambitious soldier. Success in part followed the Royal Army, until the spirit of the soldiers sunk under the moist and sultry climate of Bengal and their numbers were thinned by the sickly season that followed the periodical and heavy rains. No sooner were the roads suited for travelling, than the troops deserted in numbers. The Emperor was compelled to retreat, but was intercepted by Sher Shah, and after a delay of several months, the Emperor's camp was completely surprised and dispersed.'

Metcalfe then repeats one of the many legends about Humayun's adventures:

'Hoomaioon had not a moment for deliberation, but plunged at once on horseback into the Ganges. Before he could reach the opposite bank, the horse was exhausted and sunk into the stream, and the Emperor must himself have met with the same fate if he had not been saved by a water carrier who was crossing the river with the aid of the skin used to hold water and which inflated as a bladder, supported the King's weight as well as his own.'

Despite this narrow escape there was to be no happy outcome for Humayun:

'[In 1540 he] again took the field against the Sher Shah. A general action ensued in which he was entirely and finally defeated. His army driven into the Ganges, himself in imminent danger, his horse wounded and he must have been either killed or taken, if he had not fortunately found an elephant on which he mounted, and compelled one of those whom he found with the animal to take to the stream. The opposite bank was too steep for the elephant to ascend and Hoomaioon must still have perished had not two soldiers who happened to have gained that part of the shore, tied their turbans together and by throwing one end to the Emperor, enabled him to make good his landing. Hoomaioon fled to Lahore and eventually to Persia.'

From Metcalfe's perspective Sher Shah's claim to the throne as a 'native Indian' was better than that of the Mughals. Metcalfe also points out how Sher Shah's reorganisation of the empire laid the foundations for his successor Akbar: his innovations in coinage included the prototype of the rupee and he began what was to become the Grand Trunk Road.

Nizam the water-carrier helping Humayun to swim across the Ganges after his defeat in Bihar in 1539. Dharmdas, Or. 12988, f.53

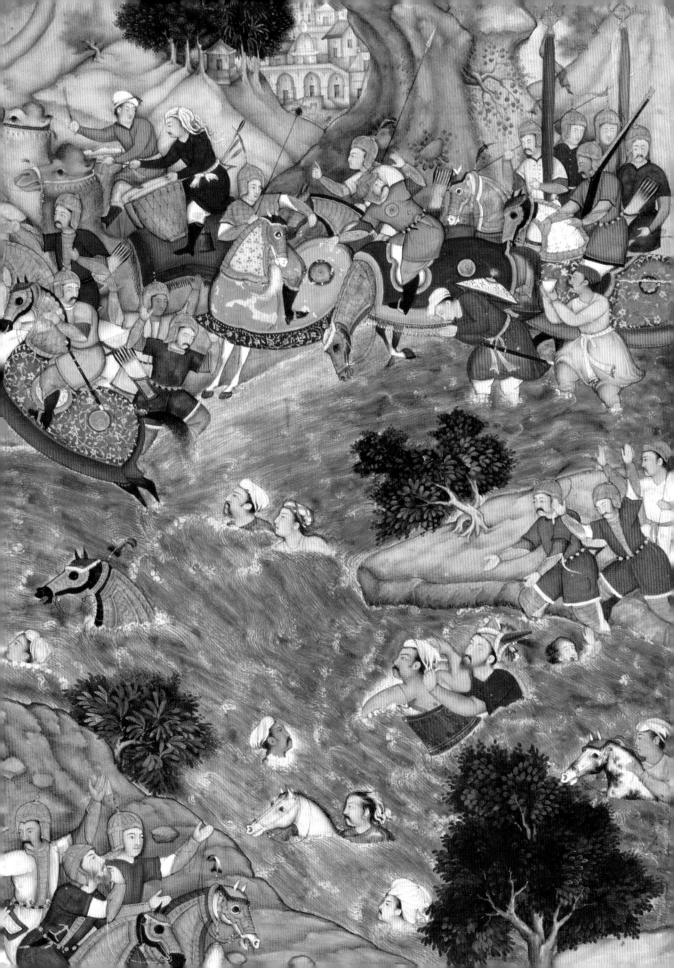

6 Humayun in Exile

In 1542 Humayun and his dwindling band of followers barely survived. In the Rajasthani desert local people had filled the wells with sand, and there were only berries to eat, or horsemeat, which Humayun's party boiled in their helmets. His 15-year-old queen was now eight months pregnant and when her horse died Humayun had to give her his while he rode a camel. Then, at Amarkot (now in Sindh, Pakistan), an heir was born and named Akbar. His aunt Gulbadan tells us in her memoir of Humayun that the moon was in Leo and astrologers were optimistic about this birth: Akbar would be fortunate and live a long time. And so it turned out.

Humayun took refuge at the court of the Safavid Shah Tahmasp, who ruled Persia from 1525 to 1576. He had known hard times too, at the hands of the Ottoman Turks, who had sacked his capital, Tabriz. Humayun was highly impressed by what he saw in Persia, in cities such as Tabriz, Ardebil and Herat – mosques and palaces, gardens and tombs. He also responded positively to a style of court painting that he found there, one which had become somewhat sidelined by Tahmasp's increasingly orthodox attitudes to art.

Humayun shared his father Babur's interest in the natural world. During his flight through the desert, while waiting for his single set of clothes to be washed and dried, 'a beautiful bird flew into the tent, the doors of which were immediately closed, and the bird caught; his Majesty then took a pair of scissors and cut some of the feathers off the animal; he then sent for a painter, and had a picture taken of the bird, and afterwards ordered it to be released.'

Humayun invited two of Shah Tahmasp's Persian artists, Mir Sayyid Ali and Abd as-Samad, to join him in Kabul, afer he had captured it from his rebellious brother Kamran with Persian support. They arrived there in 1549. A large painting was begun by Abd as-Samad of the princes of the house of Timur, which originally showed just Babur and Humayun, but later had other emperor portraits inserted. Back in India the two Persian artists masterminded a set of 1,400 large paintings on the fabulous story of Hamza, uncle of the Prophet, which were later to be painted by the Indian artists recruited to Akbar's studio. A fusion of Indian, Persian and other styles was starting to emerge, and would produce the classic Mughal miniature tradition with its interest in portraiture and lively depictions of the natural world.

Humayun with Shah Tahmasp (1544) c.1602–03. Sanvala, Or.12988, f.98a

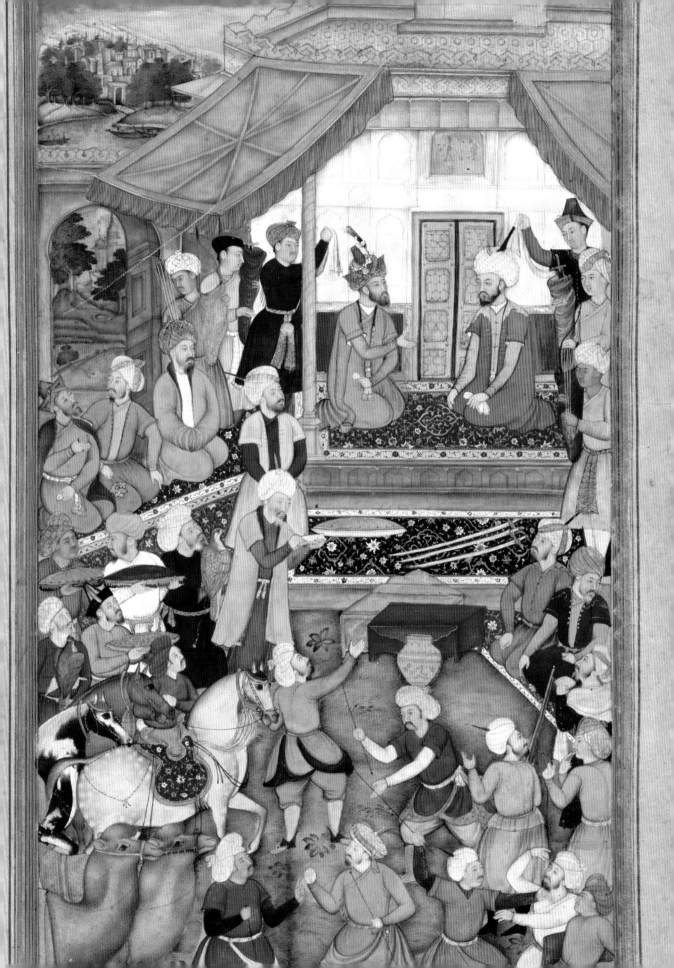

7 Humayun's Death

Sher Shah had died from burns following an explosion during a siege in 1545. His descendants were initially capable rulers, but when the regime faltered this gave Humayun his opportunity. Shah Tahmasp had given Humayun military aid to recapture Qandahar and Kabul from his rebellious brothers, but Humayun spent the next nine years constantly battling against them until they were eliminated. Discord among the Afghan princes of Sher Shah in Delhi gave Humayun his opportunity and the Mughals were soon back in India. On 23 July 1555, Humayun once again sat on Babur's throne – but not for long. He was holding court in what is now called the Old Fort, part of the new city of Delhi that Sher Shah had begun to create (two buildings still stand inside the Fort as memorials to Humayun's tragic death). He had gone up on the roof of the octagonal Library to be seen by the crowds waiting outside the nearby mosque. Inside again, Humayun, his arms full of books, heard the call for prayer at the top of the stairs, bowed in respect but tripped on his robe and crashed down the steps, breaking his skull. He lay dying for three days. He was 51.

Humayun's troubled reign is commemorated by a highly significant building not far from the site of his death. His tomb was the first major garden-tomb and was the prototype for the Taj Mahal. Begun in 1562, it was designed by an architect from Herat and refers to the monuments of the Mughals' Timurid ancestors both there and in Bukhara. It combines red sandstone and white marble (like earlier Islamic buildings in India), with symbolic six-pointed stars as a prominent part of the design. An English visitor in 1611 described rich carpets, and a small tent above the emperor's cenotaph, which was covered by a pure white sheet, with his sword, turban and shoes. Humayun's wives and later members of the family were also to be buried there. The last Mughal emperor also sought refuge here just before his arrest in 1857.

Today, with its gardens lovingly restored, Humayun's tomb presents an image of ordered calm and majesty in sharp contrast to the uncertainty and turmoil of Humayun's life and reign.

Humayun's tomb (1565), c.1820–22. Add.Or.1809

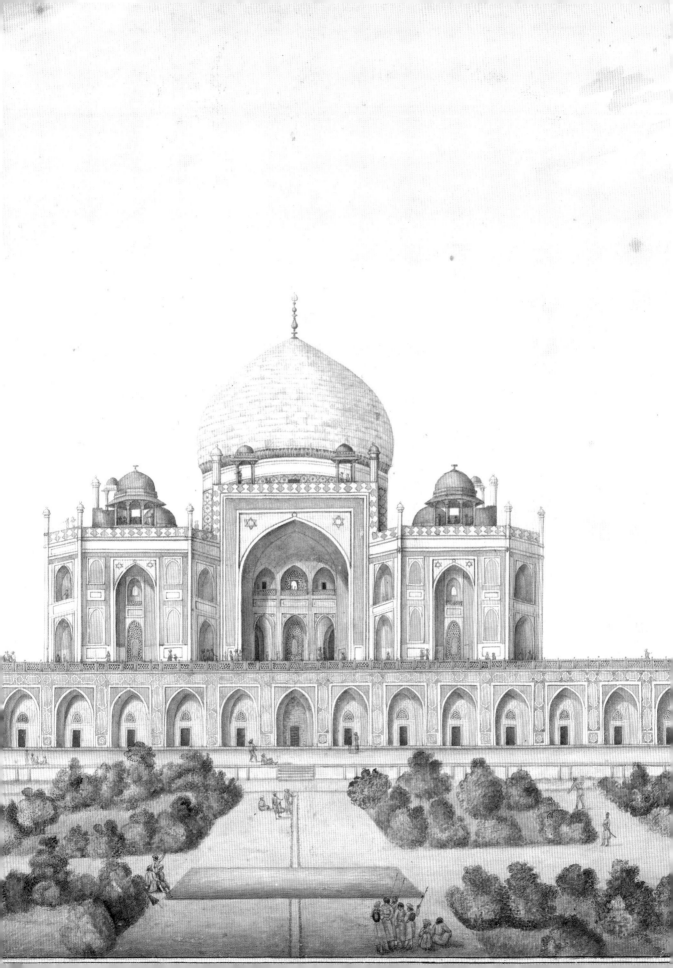

8 Akbar's Early Years

Akbar is regarded as the greatest of the Mughal emperors. His birth was astrologically blessed, but his early life was not auspicious. Akbar had been lucky to survive the chaos of Humayun's reign. His great-aunt noticed even in the three-year-old 'the very hands and feet of my brother, the Emperor Babur, and he is like him altogether'. Like his grandfather he was a young ruler, only 13 years old when he succeeded Humayun in February 1556. But, unlike his father, Akbar had inherited his grandfather Babur's qualities of willpower and focus: there was to be no easing up in Akbar's lifelong campaigns – campaigns that took place not only on the battlefield but also at court, on the building site, in the debating chamber and in the artist's studio.

His guardian, the Afghan general Bairam Khan, who had served Humayun, ruled for four years as regent. He faced an early challenge to Akbar's reign from an unlikely contender, the former superintendent of the Delhi markets. Hemu had prospered during Humayun's exile, making himself indispensable in government. Easily underestimated (given the fact that he was a general who couldn't ride a horse), he grabbed Delhi and Agra at the outset of Akbar's reign. He was killed in the early stages of the second battle of Panipat in November 1556, which the Mughals won, just as they had been victorious in the first battle. Akbar was kept safely off the battlefield until the last moment.

After four years Akbar took full control from Bairam Khan, in 1560. Akbar's main ally was now his foster-brother, Adham Khan. Foster-brothers were the sons of imperial wet-nurses, who frequently schemed behind the scenes in the interest of their own families. Akbar talked of being connected to his many foster-brothers by a 'river of milk'. However, it was not long before Akbar also fell out with Adham Khan after his brutal treatment of the defeated people of Malwa, an old kingdom in north central India. He also kept most of the loot from this campaign himself and Akbar had to order him to hand it over. Adham Khan retaliated by killing the minister who had replaced him at court in Agra. Armed and angry, he burst in on Akbar to confront him. Punishment was swift – Akbar struck him down and ordered him to be thrown from the palace terrace, but he didn't die. He was thrown again and this time he was killed. Despite what had happened Akbar gave him and his mother an imposing tomb in Delhi.

The following years were to confirm the opinion of a European observer that Akbar 'has an acute insight, and shows much wise foresight both in avoiding dangers and in seizing favourable opportunities for carrying out his designs.'

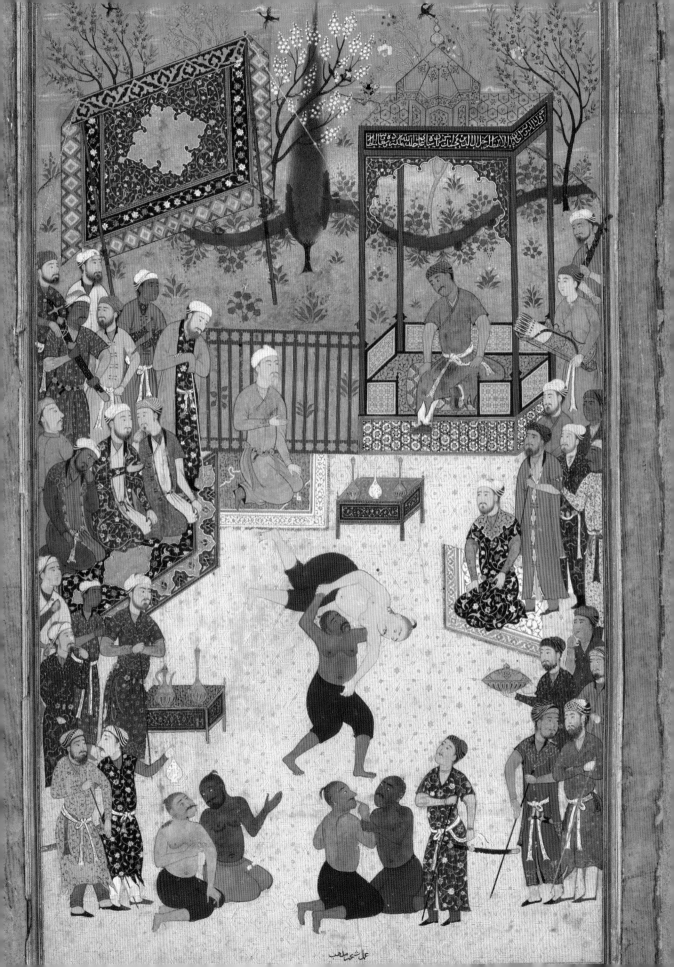

9 Akbar the Man

This account of Akbar's appearance is by the Jesuit Father Antonio Monserrate, who was in India from 1574. Akbar invited him to court from Goa; he taught Akbar about Christianity and became a tutor to one of Akbar's sons:

'One could easily recognise … that he is King. He has broad shoulders, somewhat bandy legs well suited to horsemanship, and a light brown complexion. He carries his head bent towards the right shoulder. His forehead is broad and open, his eyes so bright and flashing that they seem like a sea shimmering in the sunlight. His eyelashes are very long … eyebrows not strongly marked. His nostrils are widely opened as though in derision. … He shaves his beard but wears a moustache. He limps in his left leg though he has never received an injury there. … He is sturdy, hearty, and robust. When he laughs his face becomes almost distorted. His expression is tranquil, serene, and open, full of dignity, and when he is angry, awful majesty.'

Monserrate provides examples of both the benign and the angry, awful majesty of Akbar:

'It is hard to exaggerate how accessible he makes himself to all who wish audience of him. For he creates an opportunity almost every day for any of the common people or of the nobles to see him and converse with him; and he endeavours to show himself pleasant-spoken and affable, rather than severe, toward all who come to speak with him. It is very remarkable how great an effect this courtesy and affability has in attaching to him the minds of his subjects.'

On the other hand:

'all are afraid of his severity, and strive with all their might to do as he directs and desires. For the King has the most precise regard for right and justice in the affairs of government … by the King's direction all capital cases, and all really important civil cases also, are conducted before himself. He is easily excited to anger, but soon cools down again. By nature moreover he is kindly and benevolent, and is sincerely anxious that guilt should be punished, without malice indeed, but at the same time without undue leniency. … Those who have committed a capital crime are either crushed by elephants, impaled, or hanged. Seducers and adulterers are either strangled or gibbeted.'

It has been suggested by modern writers that Akbar was dyslexic, mildly epileptic (he went into trances) and subject to depression. However, none of these drawbacks prevented his lifetime of achievement. In 1578 when hunting at Bhera in the Punjab he experienced a mystical vision as depicted here. He stopped the hunt and had all the captured animals freed.

Akbar experiences a mystical vision during a hunt, *c.*1590–95. Johnson Album 8, 4

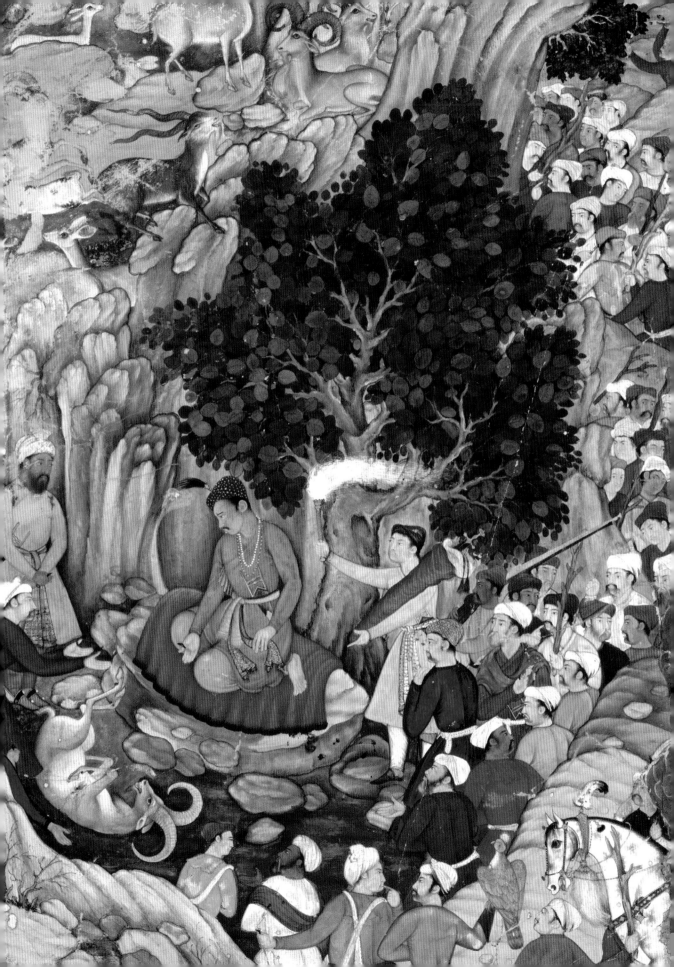

10 Akbar and Religion

Akbar famously practised religious tolerance. He showed respect for the Hindu faith from the start of his reign. For example, his wives from the Hindu Rajput royal houses were not forced to convert, and Hindus were also prominent at court and in the army. Monserrate tells us that he 'has about twenty Hindu chieftains as ministers and counsellors to assist both in the work of governing the empire and in the control of the royal household. They are devoted to him, and are very wise and reliable in conducting public business. They are always with him, and are admitted to the innermost parts of the palace, which is a privilege not allowed even to the ... nobles.' Akbar also supported Hindu temples and Christian churches as well as mosques. Non-Muslims did not have to pay taxes that supported mosques and their good works.

Akbar was a good listener, as Monserrate tells us:

'He had the power of great memory and judgment, the patience of listening to others and the ability to join in the discussion enthusiastically. He knew about a great many things and he was constantly learning. Not only did he compensate for his ignorance of things written ... he explained things plainly and simply. Although he was totally ignorant of reading and writing no one who did not already know this would think he was illiterate.'

He initiated weekly religious debates between Muslims, Hindus, Jains, Christians, Jews and Zoroastrians. Akbar was disappointed by the inability of his Muslim clerics to counter the arguments of other faiths and by the acrimony of the debate, and eventually abandoned them. He celebrated festivals of different faiths at court and adopted some of their beliefs. He became a vegetarian under Jain influence ('it is not right that a man should make his stomach the grave of animals', he declared) and didn't share the taste in drinks and drugs of other Mughals. He extended his pantheism to embrace sun worship, Zoroastrian fire ceremonies and Hindu devotion in a new court religion known as the Din-i-Ilahi ('Faith of the Divine'). Akbar also reasserted his supreme authority over all Muslims in India. Monserrate was deeply impressed by Akbar's interest in, and respect for, other religions, but amazed that he had survived, despite wide disapproval by other Muslims:

'For in spite of his very heterodox attitude towards the religion of Muhammad, and in spite also of the fact that Musalmans regard such an attitude as an unforgivable offence, Zelaldinus [Akbar] has not yet been assassinated.'

This illustration is from the Persian translation of one of the two great Hindu epics. Akbar commissioned translations of both of them in the 1580s as well as of other Sanskrit texts and had copies distributed to his family and chief nobles to further mutual understanding.

Krishna telling Bhima of Arjuna's exploits, 1598. Banvari Khurd, Or.12076, f.95

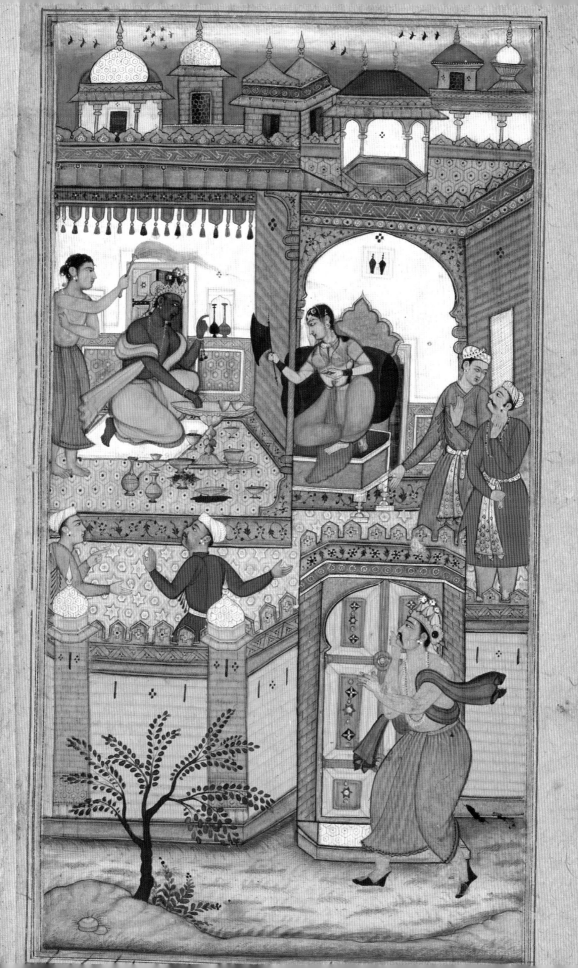

11 Akbar as Patron

Akbar was the first great Mughal patron of painting and especially of illustrated histories. Illiterate himself, he had books read to him and was especially keen to have images of what was described. Like everything else he did, he was ambitious in what he commissioned, employing around 300 artists, far more than his descendants. These artists included Persians (beginning with Mir Sayyid Ali and Abd as-Samad brought back by Humayun) as well as local Muslims and Hindus. They worked at Fatehpur Sikri and then Lahore and Agra, and their art incorporated Persian, Indian and European elements. What emerged was a distinctively Mughal style developed in, for example, the 1,400 paintings of the *Hamzanama*, the mythical adventures of the Prophet Muhammad's uncle.

Dasvant, reputedly Akbar's favourite artist, was the son of a palanquin-bearer at court and, according to Abul Fazl, 'urged by a natural desire, used to draw images and designs on walls. One day the far-reaching glance of His Majesty fell on those things and, in its penetrating manner, discerned the spirit of a master working in them … In just a short time he became matchless in his time and the most excellent, but the darkness of insanity enshrouded the brilliance of his mind and he died, a suicide. He left several masterpieces.' Dasvant illustrated the 'Tales of a Parrot' and also depicted creatures such as monkeys with great vigour, but is best known for his fantastical other-worldly scenes.

Daulat painting the calligrapher Abd al-Rahim, illustration from Akbar's *Khamsa* of Nizami 1609–10. Daulat, Or.12208, f.325b

فلک را جشمت گرانیده دار 		 برو داد و دین هر دو پا پایدار 		 اتمام یافت وانجام پذیرفت این کتاب گرامی بر رسم خواست

و کتابخانه عالی سبب کار چهضرت خلافت بناهی ظل اللهی خهر خهر و هان فاق سراع جهان افروز نه طاق ثابت انوای تخت

و دسم فرمان فرمای هفت اقلیم شهپوار سعادت رخش ملک پیمان جهان بخش قدرنشا پس کو هر هنر مندان رفعت بخش یابخت

مبندان دریای موج حنیه عالم جود سپهر حمکت آرای جهان جود رفعت رای او زنگ سپرلوازی 		 ابوالفتح جلال الدین مح سلک اکبر

اقبال لطع ای عندای آنحضرت
سپرلندی بد بعبرت پاکان پاک نهان
تمت تم

Akbar's tastes changed, and he came to prefer the more naturalistic work of the painter Basavan whose brushwork was freer, and who was good at representing character, drama and space. The emphasis now was on dynastic histories depicting events in realistic detail as if they were happening at Akbar's court. Babur's memoirs were translated into Persian and extensively illustrated (*see* 1 and 2). In 1590 Akbar also commissioned the *Akbarnama*, his official biography, with text by Abul Fazl, compiled using records of Akbar's reign kept in great detail by a team of 14 clerks. Akbar was also a pioneer oral historian, commissioning memories of his ancestors from his elderly relatives and courtiers. Like all the Mughal emperors he had a clear eye on history and his part in the Timurid epic.

The process of producing the sumptuous manucripts of the Mughal era varied. The calligrapher would always write the manuscript, leaving spaces for illustrations. In the collaborative projects of the 1580s and early 1590s, the composition was sketched in outline by a senior artist. A colourist then applied successive thin layers of paint, mostly from minerals but also vegetable dyes, with brushes made of squirrel's tail or camel hair. A glowing finish was produced by rubbing with an agate burnisher. From the mid-1590s, normally only one master artist was responsible for the paintings.

Portraits of people other than emperors were another of Akbar's innovations: 'At His Majesty's command portraits have been painted of all of His Majesty's servants and a huge album has been made. Thus the dead have gained a new life, and the living an eternity' (Abul Fazl). The determined character of the Governor of Kabul is captured well here. Below, two pigeons are shown courting by a gold dovecote, added when the portrait was placed in a later album.

Akbar's foster-brother Zain Khan Koka, *c.*1595. Inayat, Johnson Album 18, 18

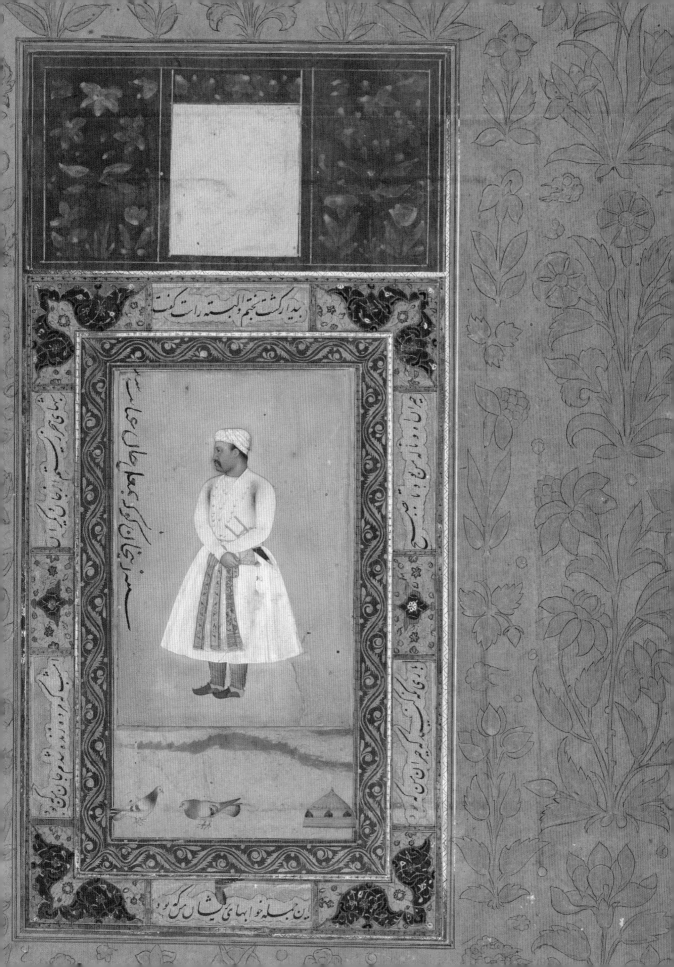

12 Akbar the Builder

'The splendour of his palaces approaches closely to that of the royal dwellings of Europe. Unlike the palaces built by other Indian kings, they are lofty; [he] is so devoted to building that he sometimes quarries stone himself ... Nor does he shrink from watching and even himself practising, for the sake of amusement, the craft of an ordinary artisan. For this purpose he has built a workshop near the palace, where also are studios and work-rooms for the finer and more reputable arts, such as painting, goldsmith-work, tapestry-making, carpet- and curtain-making, and the manufacture of arms. Hither he very frequently comes, and relaxes his mind with watching at their work those who practise these arts'.
Antonio Monserrate

Akbar was the first great Mughal builder. His early years had been nomadic but he was now able to put down roots. He could also begin to rely on more regular income from taxes rather than the fruits of war. After his projects in Delhi, including Humayun's tomb, he began the Agra Fort, a complex of 50 or so buildings constructed at speed in eight years by thousands of builders. It is in a distinctively new style: local craftsmen evolved a fusion of Hindu styles from Bengal and Gwalior with the traditions of central Asia.

The interior of the so-called Divan-i Khas in the palace at Fatehpur Sikri, 1815. Sita Ram, Add.Or.4854

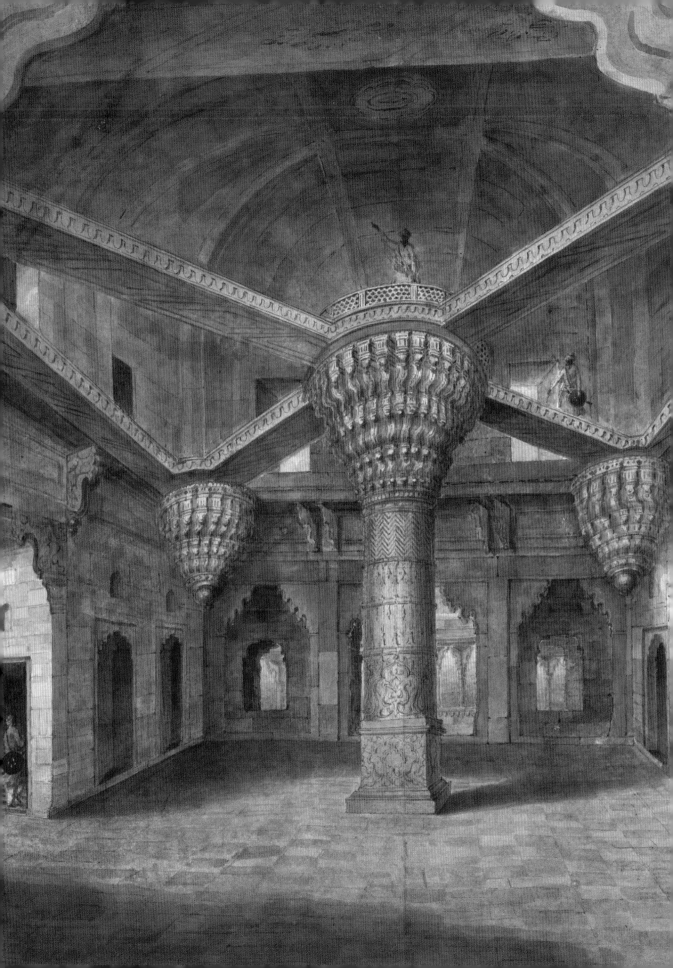

The most remarkable of his projects is the city he built between 1571 and 1585 near Agra at Fatehpur Sikri ('City of Victory', celebrating the conquest of Gujarat). Akbar, who had despaired of fathering an heir, decided to build a new city after the mystic Salim Chishti, whose hermitage was there, had correctly predicted that Akbar would have three sons. Built from the red sandstone of the ridge it stands on, here the predominant architectural influence is from Gujarat. Throughout the palace stone imitates wood in intricate canopies and screens. The modern entrance is through a monumental triumphal gate giving access to a great courtyard in front of the mosque (where Akbar often led prayers and reputedly swept the floors as an act of devotion). In contrast to these imposing sandstone structures is the delicate marble tomb of Salim Chishti, where mothers hoping for sons still tie threads. The old entrance to the palace is from the north-east, through the courtyard with the Public Audience Hall. Between it and the mosque are the more private quarters. To ensure cool serenity, the houses of Akbar and his main wives were well ventilated, and grouped around pools. The most extraordinary room is the Divan-i Khas, the Private Audience Hall. In the centre of the room is an elaborately carved pillar, supporting a circular platform with access by four walkways that criss-cross the space. It was here that Akbar sat and presided over council meetings.

Fatehpur Sikri was abandoned a decade later, supposedly because there was insufficient water to support a growing population. To deal with trouble in the north-west, Akbar moved to Lahore where he built another major royal fort, and finally returned to Agra at the end of his reign. There was no Mughal capital city as such, as Akbar moved around his empire as imperial needs dictated and built accordingly. His successors followed suit.

View of the dargah (shrine) of Shaikh Salim Chishti and the tomb of Islam Khan beside it in the courtyard of the Great Mosque at Fatehpur Sikri, 1815. Sita Ram, Add.Or.4852

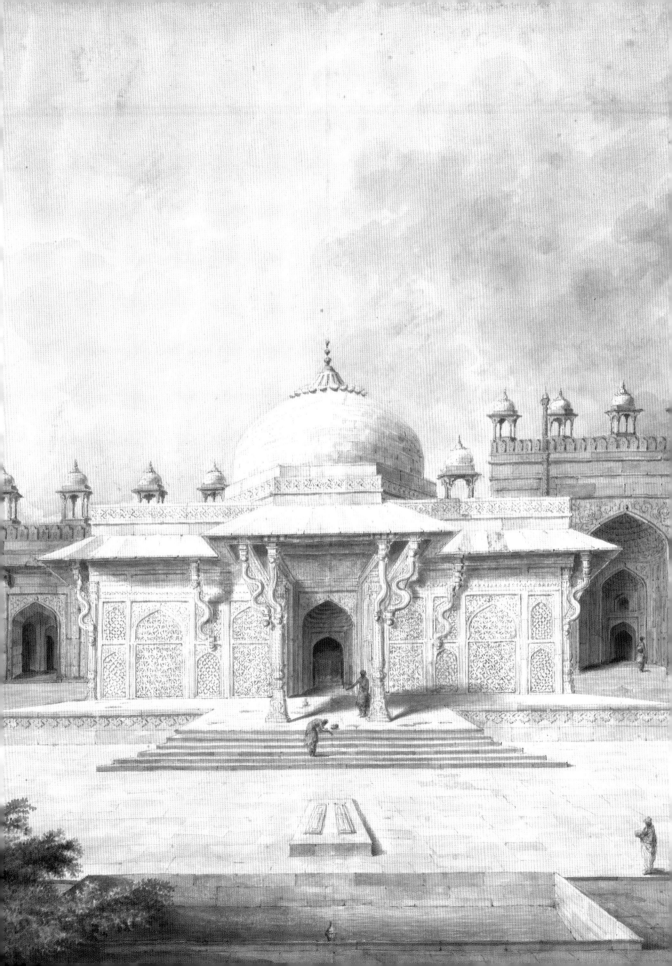

13 Akbar and Europeans

Akbar was fascinated by foreigners and took every opportunity to interview them and get their opinions. The Jesuit Antonio Monserrate tells us that he was moved into a room near the emperor so they could talk late into the night. He 'receives foreigners and strangers in a very different manner to that in which he treats his own fellow-countrymen and subordinates. For he behaves with marked courtesy and kindliness to foreigners, especially to the ambassadors of foreign kings, and to princes who have been driven from their dominions and appeal to him for protection … He is very fond of carrying a European sword and dagger … He much approves the Spanish dress, and wears it in private … He has a velvet throne of the Portuguese type carried with him on a journey, and very frequently uses it.'

The Portuguese explorer Vasco da Gama had reached India in 1498, and by 1510 the Portuguese were well established in Goa, and controlled much of the west-coast sea trade. St Francis Xavier, the great Jesuit missionary, arrived in Goa in 1542 and his relics are still venerated there. By the end of Akbar's reign, Goa (the 'Rome of the East') was the splendid capital of a maritime empire that stretched from Africa to Japan and dominated the Indian Ocean. The Portuguese also had bases around Madras and in Bombay (which was ceded to Britain in 1661 as part of the dowry of Charles II's queen). This was their heyday before first the Dutch and then the French and British competed for the lucrative trade of the Indies. Thomas Stephens, a Jesuit, was probably the first Englishman to set foot in India, and he died there in 1619.

Once Akbar had annexed Gujarat, and particularly after the siege of Surat in 1572, a rapprochement developed: Akbar welcomed a Portuguese ambassador and Jesuit priests at court, though they were unpopular with Muslim priests and many courtiers. Monserrate's memoirs reveal how persistently the ambassador and his colleagues criticised Islam and in particular the Koran. Monserrate also berated Akbar over Hindu practices such as *sati* (the custom of self-immolation by women on their husband's funeral pyre).

This Mughal painting of Europeans from the end of Akbar's reign shows local artists taking account, however awkwardly, of European originals brought from Goa. Akbar valued the realism of European art, and some of his artists specialised in copying prints and paintings exactly. This painting shows a mix of ancient and modern European dress, a north European-style landscape at top right, an adapted religious scene in the centre, and below a drinking party. Mughal artists also adopted the halo from Christian art, and emperors such as Jahangir are shown with one to reflect their imperial status.

Europeans, *c.*1590. Johnson Album 16, 6

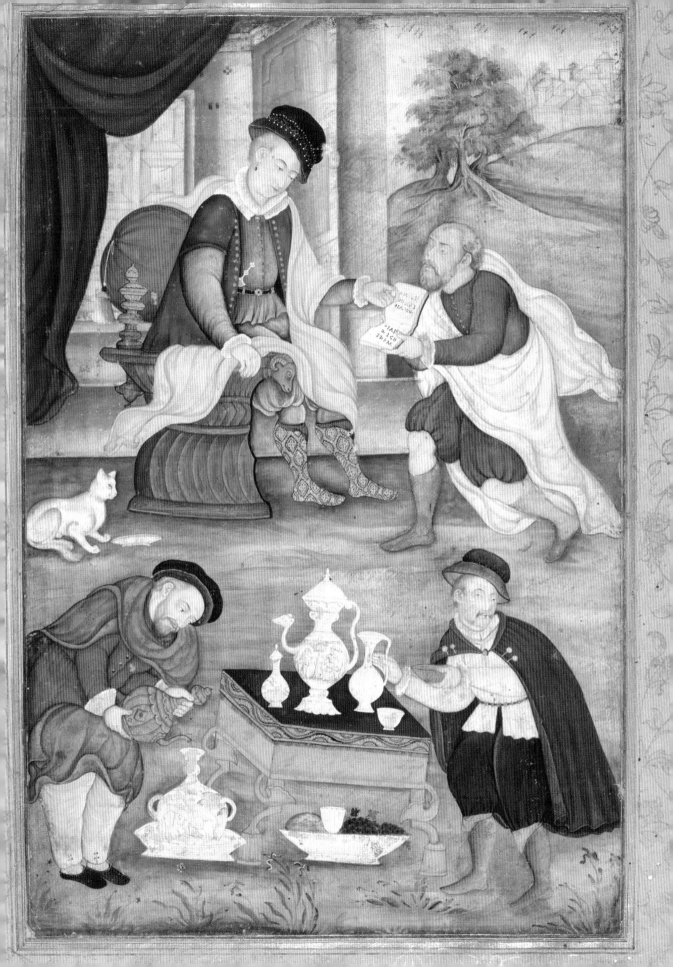

14 Akbar's Heavy Cares of State

'… and this realm is indeed a vast one'.
Antonio Monserrate

Akbar observed: 'An Emperor shall be ever intent on conquest, otherwise his enemies shall rise in arms against him.' He greatly extended his inherited kingdom from a core in central northern India and the Punjab to encompass Gujarat to the west and Bengal to the east. Gujarat was important for its ports and lucrative trade, particularly in textiles, and its links with the Arab world and Ottoman Turkey and Europe. Akbar formed alliances, often by marriage to the great Rajput families. When rulers resisted, he besieged their strongholds: after Chitor fell thousands were killed and a great tower of skulls warned others not to follow suit. Based now in Lahore, Akbar consolidated his control over Afghanistan – the traditional Mughal bolthole – and the Indus valley. Only then, in 1598, did he feel able to return to Agra. He then pushed on towards the south in the Deccan, a mission to be continued by all his descendants.

The young Akbar had been hyperactive and, instead of learning to read and write, had been passionate about riding, wrestling, fencing, flying pigeons, archery and shooting. Monserrate observed later: 'As he is of a somewhat morose disposition, he amuses himself with various games. … However, although he may seem at such times to be at leisure and to have laid aside public affairs, he does not cease to revolve in his mind the heavy cares of state.' Akbar was also a demanding father to his three sons, two of whom died of drink before him. His heir prince Salim (later Jahangir) was also addicted like his ancestors to drink and opium. Towards the end of Akbar's reign Salim staged a revolt against him and even issued coins in his own name. Finally, under pressure, and amid suggestions that his own son Khusrau should succeed instead of him, Salim faced Akbar at Agra in 1604. His father slapped his face and punished his followers. A drawing probably from these years shows a careworn Akbar. He was worn out by constant campaigning, and grieving the loss of his much-loved mother, and no doubt concerned about the future of the empire under his heir. In October 1605 Akbar fell ill with dysentery and didn't recover. He was 63. He was buried in his mausoleum west of Agra at Sikandra, which Jahangir completed in 1613. The inscription over the gate refers to the garden within: 'These are the gardens of Eden, enter them and live forever.'

Drawing of Akbar as an old man, *c.*1600. Add.Or.1039

15 Jahangir

One of the sources for the reign of Jahangir is the 'Journal of the Mission to the Mogul Empire' by the British ambassador Sir Thomas Roe, who was in India from 1615 to 1619 seeking a trade treaty and protection for an English base at Surat in Gujarat. He probably exaggerates his own intimacy with the emperor (who apparently gave him presents, including fat hogs from Goa) but he does give a good idea of the pace and uncertainty of court life and events. In his account Jahangir appears strong, capable and benign except when provoked: 'He is very affable and of a cheerful countenance … full of gentle conversation … the wisdom and goodness of the king appears above the malice of others.'

Akbar bequeathed to his 36-year-old son a well-organised state which collected taxes and statistics, audited accounts, promoted trade and agriculture, and fostered harmony between faiths and cultures. Jahangir ('World Seizer') was thus spared the uncertainty with which his predecessors began their reigns. This portrait of him as he may have appeared aged 20 was actually painted when he was around 50. It captures his refinement as he admires a pink rose – but doesn't hint at his dissolute life as a prince nor his sadistic streak. Like his father he was a great connoisseur of painting, and even as a prince he already had his own artists in Allahabad. He claimed that he could instantly distinguish one artist from another. He dismissed some of his father's artists because their work was not to his taste, and preferred single artists working on paintings rather than teams. He also preferred albums of naturalistic studies of nature and animals, court scenes and portraits, and Europeanised subjects rather than the copious book illustrations of his father's reign.

Politically, Jahangir's reign was turbulent. A series of revolts in the Deccan to the south, led by Malik Ambar, threatened to roll back the frontiers of the realm that Akbar had left his son. Another worry was the loss of strategically important Qandahar in Afghanistan, recaptured by the Persian Shah Abbas while Jahangir was dealing with turmoil elsewhere.

Jahangir's memoirs show a characteristic Mughal attention to detail. He mentions ordering shady trees and resting places to be positioned along the trunk roads from Lahore to Agra and all the way to Bengal. He also recounts the trials of strength and skill by his entourage, and the antics of conjurors and magicians. But his memoirs are also imbued with a more sombre, twilight mood: he comments darkly that 'the jewels of this world which have been poured in such profusion on my head … bear no longer any value in my sight … the enjoyments of hunting and of social mirth have too frequently been the source of pain and regret'. Jahangir shows here that he was more the son of Akbar than had seemed likely at his accession.

Jahangir depicted as a young man, c.1620. Add.Or.3854

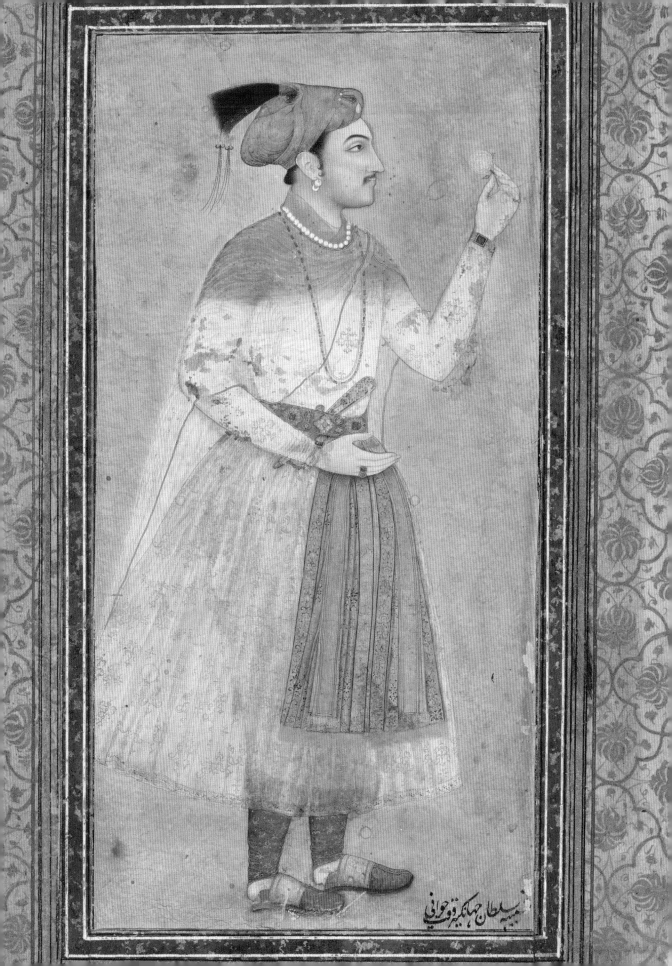

سلطان جهانگیر قوت جوانی

16 'The Treasury of the World'

Sir Thomas Roe was so astounded on seeing Emperor Jahangir adorned in all his finery, that he described him as 'the treasury of the world'. Roe describes the twice-yearly ceremony of weighing the emperor, awash as usual on state occasions with diamonds, rubies 'as great as walnuts' and pearls 'such as mine eyes were amazed at'. He was weighed against bags of silver, then gold, then jewels in the other scales of the balance, and an amount equal to his weight was then distributed to the poor. Courtiers all scrambled for the fruits and nuts that the emperor cast around the room.

During the New Year festival of 1611, around the time of this painting, Jahangir met the formidable Nur Jahan ('Light of the World'). He was so infatuated by her that they were married two months later. She became the real power behind the throne, with Jahangir weakened by his addictions to drink and opium (appropriately he is shown holding a cup on his coinage). Her father is the chief minister in the painting and her brother, a future chief minister, stands next to him. Nur Jahan was unconventional – she had refused to be put in the harem, and even went tiger hunting with her husband.

This painting of Jahangir with two of his sons was inserted into a pocket edition of the poems of Hafiz, a text which Jahangir used for taking auguries. Khurram presents what appears a rather modest tray of jewels to his father. His elder brother, the weak and alcoholic Parviz, looks on below the emperor to the left. Jahangir's chief minister Itimadal-Daula, 'Pillar of the State', is behind Khurram, along with his son Abul Hasan whose daughter Mumtaz Mahal was betrothed to Khurram in 1611. It is interesting how the complexions of the courtiers are differentiated. The highly adept artist may be Govardhan, who painted another similar scene.

In his memoirs Jahangir reflected on the impermanence of everything: 'Remember, my son, that this world is no permanent possession. It offers no resting-place, either for reliance or hope.' This was the story of his reign. Roe hinted in his memoirs in 1616 that there would be terrible 'combustion' as a result of Jahangir's sons struggling to succeed him. His eldest son Khusrau, then aged 18, rebelled against his father one year into the new reign and was blinded as punishment, and later murdered by his younger brother Prince Khurram, the future Shah Jahan and Jahangir's favourite. He in turn at the end of the reign also rebelled against his father. This pattern would repeat itself in the next reign too.

Jahangir presented with jewels by Prince Khurram, c.1611. Or.7575, f.249a

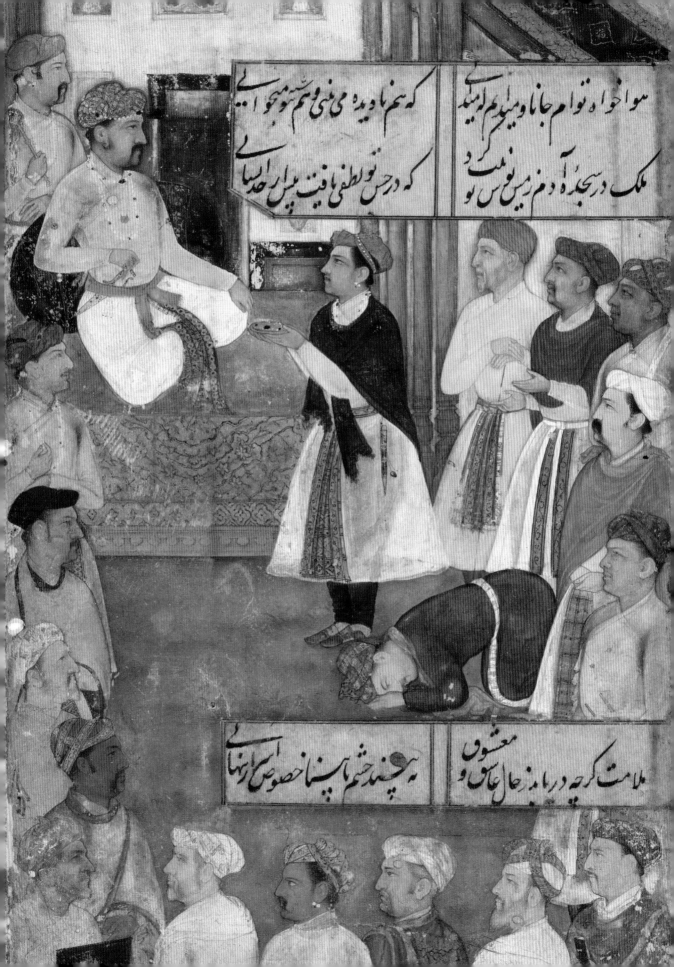

Jahangir the Hunter

Jahangir turned out a better ruler than many at court had feared when they proposed his son instead. As lawgiver he is famous for the golden chain of justice with its 60 bells, which was hung between the river and the royal fort at Agra. Anyone complaining of injustice by his officials could pull it and bring their case to Jahangir's attention. Jahangir was not a conventional Muslim, and Sir Thomas Roe even thought he was an atheist. He took astrology and dreams very seriously. Like his father, Jahangir listened to and respected many different religions – in one painting he is shown with a naked Hindu hermit. He also displayed Christian images along with portraits of foreign rulers, such as James I, in gilded picture galleries that impressed foreign visitors. Jahangir did, however, tangle with Sikhism and had one of its gurus executed in 1606, ostensibly for his support for the rebellious Khusrau. Late in his reign and fragile as a result of his addictions, Jahangir turned increasingly to religion for solace, and wrote: 'Although we have the business of kingship before us/ Every moment we think more and more on the dervishes…'

Like his ancestors Jahangir was a keen hunter. He records that he killed over 30,000 birds and beasts. At the same time he was an observer of nature and encouraged his artists, notably Ustad Mansur, to depict it. His memoirs include comments on the gestation period of elephants and the mating of cranes. The painting here shows the artist Abul Hasan at his lyrical best with a beautifully choreographed ballet of red squirrels while deer rest in a Persian-style landscape. Jahangir was not a great builder, but he did make a monument to one of his pet deer. He commissioned the famous Shalimar Gardens by Lake Dal in Kashmir, and completed his father's tomb at Sikandra and other buildings in Lahore. Nur Jahan created a beautiful garden and tomb for her father Itimad al-Daula in Agra, in white marble encrusted with cornelian, onyx, jasper and other semi-precious stones. She is buried alongside Jahangir near Lahore. His tomb is decorated with tulips and cyclamen in semi-precious stones; her tomb has an inscription: 'On the grave of this poor stranger, let there be neither lamp nor rose. Let neither butterfly's wing burn nor nightingale sing.'

While he was on his way to Kashmir in 1626, Jahangir was captured by rebels and had to be rescued by an army of supporters gathered by his wife. He died the following year, prompting the usual dynastic power struggle in which many possible claimants to the throne had to be disposed of before Prince Khurram could ascend it as Shah Jahan.

Squirrels in a plane tree, *c*.1605–08. Abul Hasan, Johnson Album 1, 30

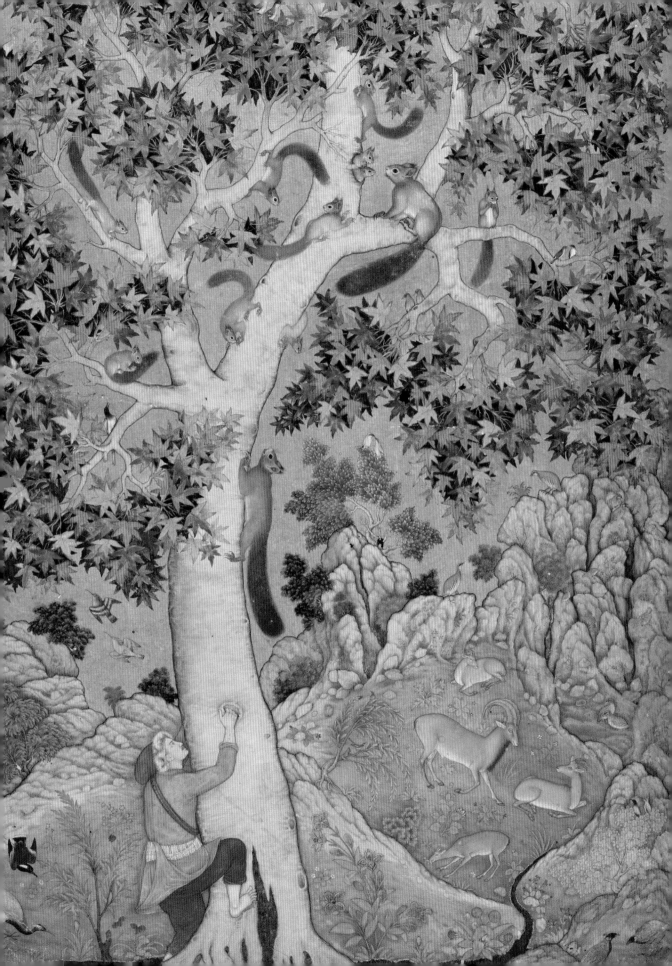

18 Passing the Throne to Shah Jahan

Shah Jahan ('King of the World') had been a favourite grandchild of Akbar, who gave him his princely name Khurram ('joyful'). He had already proved himself in his father's reign as a successful general. This preparatory drawing is one of several versions of this scene destined for the imperial copy of the official history of Shah Jahan's reign. Unusually, Jahangir has risen from his throne to greet his son on his triumphant return from the Deccan in 1617. As Jahangir said in his memoirs: 'The length of our separation had been eleven months and eleven days. I summoned him up into the jharokha, and, out of sheer love and yearning, I involuntarily rose from my place and embraced him.' It shows the artist building up the portraits of individual courtiers (some of them holding trays of jewels, the spoils of the Deccan campaign), the architectural detail of the throne balcony (jharokha), and his delight in capturing the personality of elephants, a particular passion of Jahangir's.

Shah Jahan emerges as a rather aloof perfectionist, put on a pedestal as a symbol of the just Islamic ruler. He was extremely critical, and didn't indulge in drink and drugs like his father. Roe described him when younger as cool and haughty in manner: 'I never saw … any man keepe so constant a gravity, never smiling… but mingled with extreme pride and contempt of all. … yet I found some inward trouble now and then assayle him and a kind of brokenness and distraction in his thoughts'. He was, however, a very hands-on ruler, travelling around his kingdom to be seen and to enforce Mughal authority and central control, not least on taxation. Unlike Akbar and Jahangir, he was an orthodox Islamic ruler. He restricted both Hindus and Christians from building, and killed Christian prisoners if they did not convert to Islam.

He was frequently on campaign: although he failed to dislodge the Persians from Qandahar he did consolidate control over the Deccan, and saw off several other threats to his rule. But he is now remembered most for his patronage of architecture and art and his love of jewels. His most extravagant commission was the Peacock Throne, encrusted with hundreds of diamonds, emeralds, pearls and rubies. This was destined for the palace in the Red Fort in his new capital city, Shahjahanabad, now Old Delhi. He also built the massive Friday Mosque nearby. Shah Jahan had replaced many of Akbar and Jahangir's buildings at Agra with his own characteristic white marble, but he still felt that Agra was not adequate as a capital city. Shahjahanabad was twice the size, and planned with broad avenues, water channels, markets, mosques, gardens, barracks, workshops and houses for his leading courtiers and officials. He also created many gardens in Kashmir where he often spent the summer. His most famous project was, of course, the Taj Mahal.

Jahangir greets the future Shah Jahan, drawing, c.1630. J 4, 2

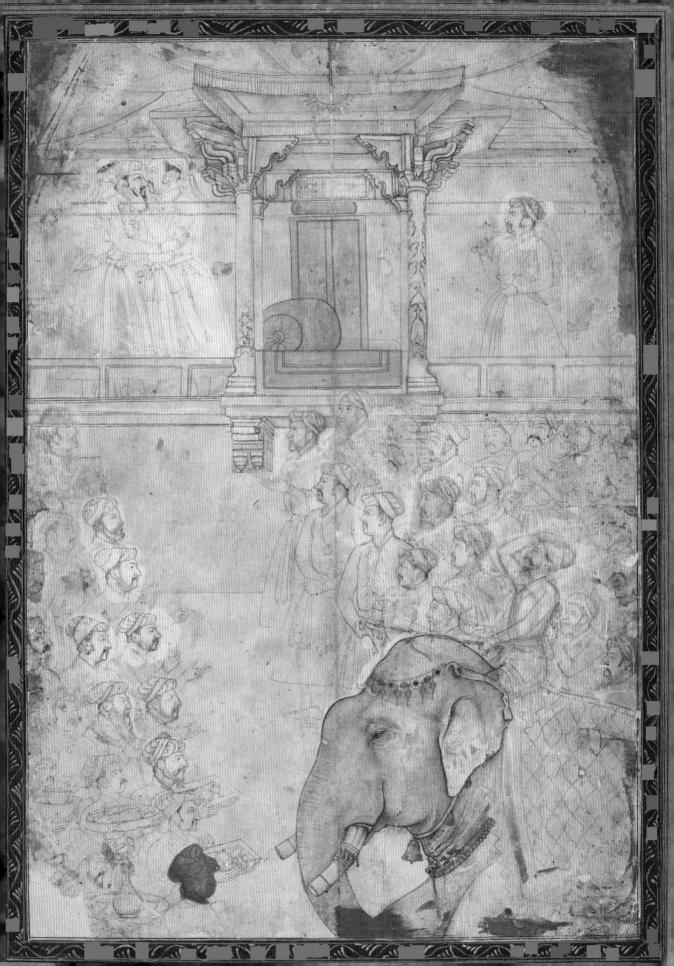

19 The Taj Mahal

Shah Jahan had the Taj Mahal built outside Agra to commemorate his beloved wife Mumtaz Mahal, who died in 1631. They had been inseparable, and his official biography, the *Padshahnama*, goes into great detail about his broken heart, and how his beard turned white overnight. Mumtaz, who was the niece of Jahangir's queen Nur Jahan, died giving birth to their fourteenth child. Her tomb was to be quite unlike those of any previous emperors. A vast labour force was assembled including marble cutters and carvers and inlay workers. The Persian calligrapher Amanat Khan wrote the passages from the Koran on the theme of judgment and reward in Paradise that were inlaid on the facades as black marble into white. Other craftsmen specialised in the exquisite flowers and vines that decorate the white marble in inlays of jasper, jade and yellow marble. Centuries later the great Indian poet Rabindranath Tagore described it as 'a teardrop on the cheek of time'.

There was also a religious programme behind this project. Moving away from the more open attitudes of his father and grandfather, Shah Jahan had reverted to mainstream Islam and used the Taj Mahal as a physical statement of its teachings. The whole complex revolves around the idea of the Day of Judgement and future reward in Paradise with the mausoleum itself seen as the house of the queen in the gardens of Paradise. Shah Jahan himself described the Taj in these words:

> Should guilty seek asylum here,
> Like one pardoned, he becomes free from sin.
> Should a sinner make his way to this mansion,
> All his past sins are to be washed away.
> The sight of this mansion creates sorrowing sighs;
> And the sun and the moon shed tears from their eyes.
> In this world this edifice has been made;
> To display thereby the creator's glory.

This view, taken from across the river Jumna, is by Thomas Daniell and his nephew William, based on sketches made in 1789. Thomas Daniell comments in the accompanying text: 'The Taje Mahel has always been considered as the first example of Mahomedan architecture in India, and consequently, being a spectacle of the highest celebrity, is visited by persons of all rank, and from all parts. This high admiration is however not confined to the partial eye of the native Indian; it is beheld with no less wonder and delight by those who have seen the productions of art in various parts of the globe … we are overwhelmed with its effect, and compelled to acknowledge it a most extraordinary assemblage of beauty and magnificence.'

Shah Jahan's grief at his wife's death did not stop him taking other wives, and they are also buried here. At the end of his reign he was incarcerated in the Agra fort by his son Aurangzeb, and could only gaze from his balcony window at the Taj in the distance.

The Taj Mahal, Agra, aquatint, drawn and engraved by Thomas and William Daniell. Published T. Daniell, London, 1801.

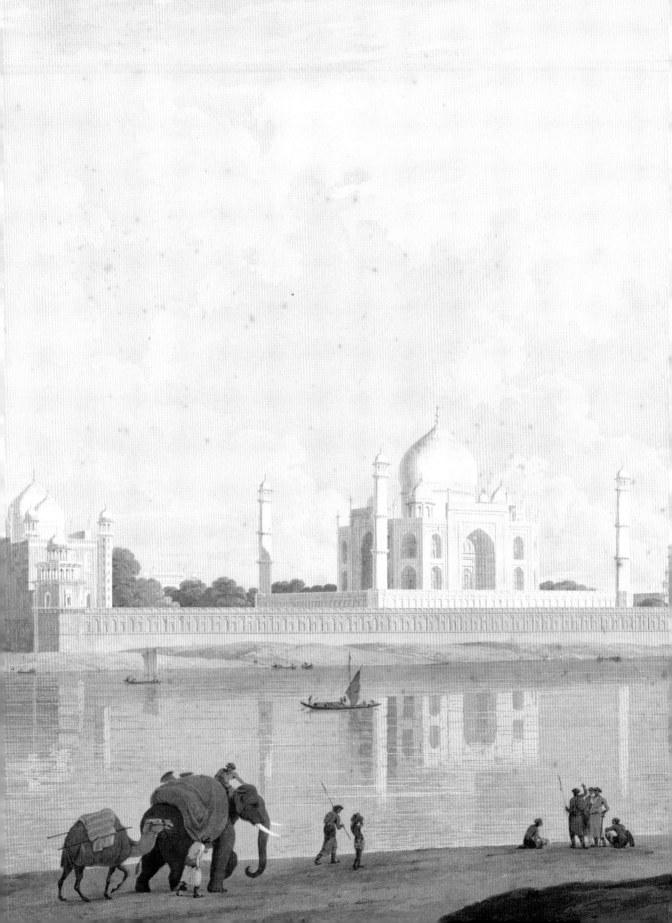

20 Women at Court

There were many women at court whose lives we know little about. Rajput princesses, for example, were married to Mughal emperors for diplomatic reasons and then often disappear from the records. There was also of course a whole army of female servants. According to foreigners at court there may have been as many as 1,000 women living separately in the harem. The harem was closed to all men other than the emperor and his sons, eunuchs, doctors and occasional relatives, and was the scene of constant squabbles and intrigues. Some of the women were Turkish, Christian and even Tartar. When the emperor went on campaign most of the harem went with him in purdah – a massive undertaking. The harem area of Akbar's palace at Fatehpur Sikri gives a good idea of the scale needed to accommodate the women, and how they were kept cool with fountains, pools and well-ventilated terraces. The Ottoman harem quarter of the Topkapi Saray palace in Istanbul is a comparable example, and still retains much of its original character.

The quality and variety of men's and women's clothing amazed foreigners as much as the opulence of jewels and court ceremony. The French doctor Bernier (who was allowed into the harem to tend sick women) commented on their exquisitely embroidered and decorated garments: 'Manufactures of silk, fine brocade, and other fine muslins, of which are made turbans, girdles of gold flowers, and drawers worn by Mughal females, so delicately fine as to wear out in one night.' Fine, fluttering women's clothes could also be a terrible fire hazard. One night in 1644 the princess Jahanara, Shah Jahan's favourite daughter, was bidding him goodnight, 'when the border of her chaste garment brushed against a lamp burning on the floor', Inayat Khan tells us. 'As the dresses worn by the ladies of the palace are made of the most delicate fabrics and perfumed with fragrant oils, her garment caught fire and was instantly enveloped in flames.' Eventually her burns healed, after Shah Jahan had helped nurse her. She would repay that debt by nursing him at the end of his life. Jahanara, like many royal ladies, was highly educated and (like her brother Dara) was interested in mystics and Sufis and wrote their biographies. She also commissioned mosques, gardens and schools (madrasas). She lived to be 70, as did Jahangir's extraordinary queen Nur Jahan – a famed beauty, a hunter, and also a designer of clothes and jewellery. She was passionate about poetry, music and art, and had a notable library. Babur's daughter Gulbadan, an author and poet, died aged 80 in 1603. She had also made the hazardous pilgrimage to Mecca.

In this 'window portrait' (probably from early in Aurangzeb's reign) a beautiful woman holds a tiny porcelain wine cup in one hennaed hand and a wine bottle in the other. She is looped with pearls, and her skirts have the characteristic flower decoration of the Shah Jahan era.

A girl at a window, c.1660. Raghunandan, J 4, 5v

زلف او زپشِانه کرصبا کردد بچشم او زپ سُرمه کرحیا کردد

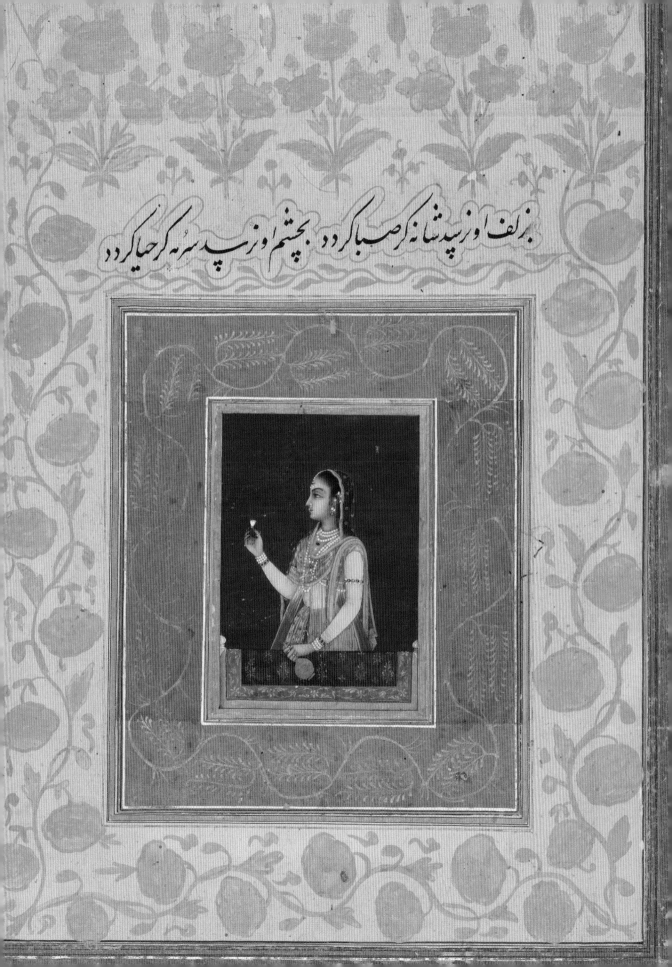

21 Shah Jahan

Shah Jahan is holding a durbar (ceremonial assembly) in the public audience hall of his palace. He is portrayed in an idealised manner, as an icon. He is shown in profile with a halo, semi-divine. He is admiring a jewel from a tray presented (top left) in tribute by Aurangzeb his second son, shown saluting (below left). The throne and balcony are decorated with the flowers characteristic of so many of Shah Jahan's buildings, such as the Taj Mahal.

Niccolao Manucci, an Italian who spent most of his life in India and author of the 'Storia do Mogor', tells us that Shah Jahan was taken seriously ill in 1657 after taking a strong aphrodisiac. Now aged 65, 'he brought this illness on himself … he wanted still to enjoy himself like a youth'. Rumours circulated that he was dead. In the power struggle that erupted 'the unhappy king saw that his sons had lost all respect for him neither paid they any obedience to his orders' (Manucci). It was Aurangzeb who was to triumph, but he was not the eldest and certainly not his father's favourite. This is apparent in some of the paintings of them on official occasions. Shah Jahan's favourite and heir was his eldest son, Dara Shikoh, a cultivated Sufi with wide religious interests like his grandfather and great-grandfather – he had translated the great Hindu text, the 'Upanishads', into Persian, for example. He was genial, but proud and contemptuous of many at court, and not good at taking advice. He was not prepared for a fight to the finish; Aurangzeb, on the other hand, was ruthless, conventionally Muslim and a capable politician and general. Dara Shikoh was none of these things, and the two brothers loathed each other. Shah Jahan reportedly acknowledged that only Aurangzeb had the resolve to 'shoulder this difficult task'.

In the crucial battle near Agra, Dara Shikoh appeared to be winning but failed to seize his advantage. When he stepped down from his elephant howdah (carriage) after it had been hit by a rocket, many of his followers assumed he had been killed, and deserted, leaving the field to Aurangzeb. He took Agra and imprisoned his father, who had now recovered, but was old, ill, distraught and powerless. Dara Shikoh fled with his family to Lahore. In the summer of 1658 Aurangzeb held an interim coronation durbar outside Delhi, and later took the title of Alamgir ('World Conqueror').

Shah Jahan spent eight years in captivity in Agra with his daughter Jahanara. In 1666, when his time came, his own burial was not grand like his predecessors. His body was taken from the Agra fort by boat at dawn and laid in a cenotaph beside Mumtaz. It was a sad end to a glittering reign that has left such an indelible record.

Shah Jahan in a ceremonial assembly, *c.*1650. Add.Or 3853

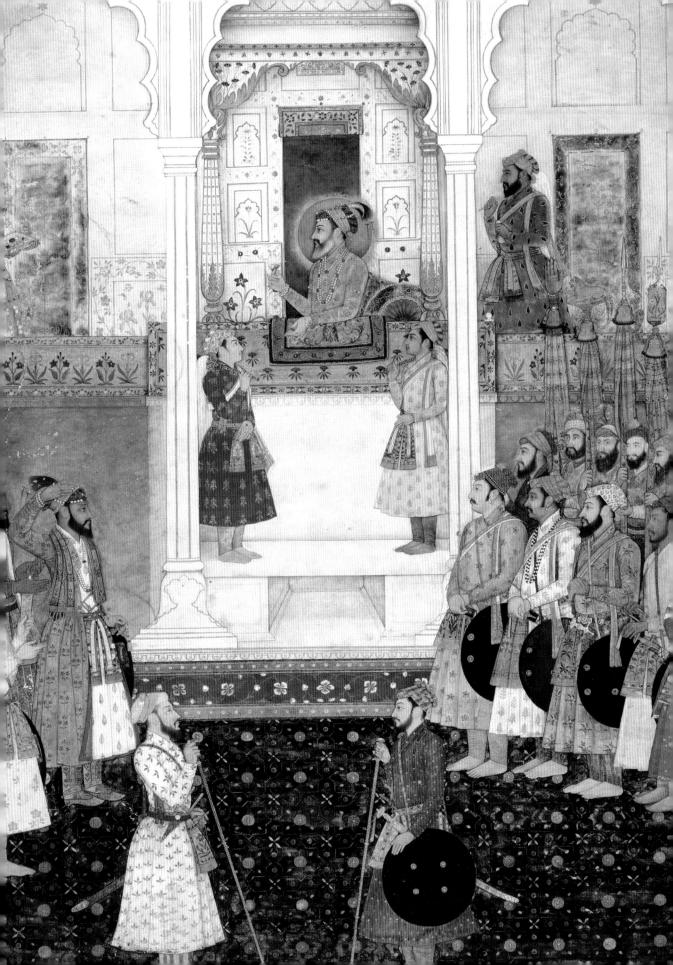

Dara Shikoh: the Failed Emperor

This portrait captures the essence of a remarkable prince. We can only speculate what kind of emperor he might have made. His tolerant, syncretist approach to Hinduism was a throwback to Akbar, but not acceptable to his nemesis Aurangzeb. Some of Shah Jahan's best painters had worked for Dara Shikoh, who also collected paintings and calligraphy from the period of Akbar's reign onwards. He assembled this lavish album for his wife Nadira Banu around his marriage in 1633. It has 79 folios and 40 miniatures, all mounted within gold-painted borders. It is one of the few Mughal albums to have survived almost complete. This page includes a pink rose, a blue iris and a pimpernel. Flower paintings like this were not always botanically correct, however: one page in the Dara Shikoh album shows a fantastic narcissus and iris blooming from a single root.

Flowers have a special place in Islamic art as symbols of Paradise, and therefore are especially appropriate for tombs like the Taj Mahal and those of Jahangir and his wife Nur Jahan in Lahore. From Babur onwards, the Mughals had appreciated and commented on flowers and commissioned paintings of them. Jahangir, for example, ordered his court artist Mansur to capture the profusion of flowers in Kashmir while there in 1620. A new 'flower style' was the result, with beautifully observed 'portraits' of contrasted blooms against plain backgrounds. The butterflies and other insects that are often depicted are a clue to European influence – they appear in the illustrated books and prints that were now available in India for court artists to use. European flowers that are unknown in India also appear in Mughal paintings. Flowers moved from the margins and the background of miniatures to centre-stage and pervade all aspects of Mughal design. In the age of Shah Jahan flowers decorated clothes, jewels, tents and carpets, furniture, and the ceilings and walls of palaces and tombs. The Taj Mahal has exquisite flowers – lily, narcissus, iris and tulip – carved in marble and often inlaid with semi-precious stones.

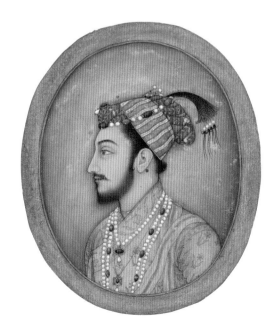

Portrait of Dara Shikoh, c.1640.
Chitarman, Johnson Album 24, 12

The Dara Shikoh album: pink rose, blue iris, pimpernel and other plants, c.1630–35.
Add.Or.3129, f.67 v

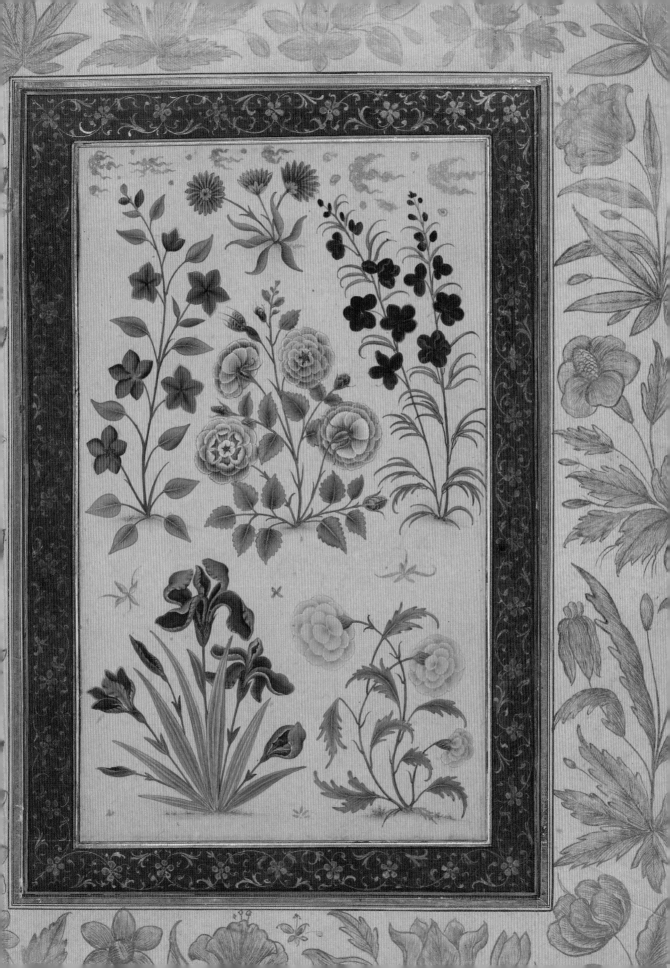

23 Aurangzeb Secures His Throne

Aurangzeb was the last and most enigmatic of the great Mughal emperors, feared but not loved. His reign was the turning point between the glory years and the years of decline.

'This prince was very different from the others being in character very secretive and serious, carrying on his affairs in a hidden way, but most energetically. He was of a melancholy temperament, always busy at something or another, wishing to execute justice and arrive at appropriate decisions. He was extremely anxious to be recognised by the world as a man of wisdom, clever and a lover of the truth... .'
Niccolao Manucci

Manucci was hardly an objective witness – he had fought for Dara Shikoh and refused to serve Aurangzeb. He refers to Aurangzeb as 'that Machiavelli' and gives a fascinatingly detailed account of how during the power struggle Aurangzeb enticed his younger brother and rival Murad Baksh into his clutches on the pretence that Murad would be emperor. Drunk and unarmed, Murad was shackled and then imprisoned in Delhi after being publicly humiliated. He was eventually executed in 1661. Of the remaining brothers, Shah Shuja began well but didn't press his lead and had to flee. He was eventually captured by an ally of Aurangzeb (who had been assiduously courting neighbouring rulers and leading nobles) and he too was killed in 1661.

Shah Jahan's French doctor, François Bernier, thought that Aurangzeb 'was devoid of that urbanity and engaging presence so much admired in Dara; but he possessed a sounder judgment, and was more skilful in selecting for confidants such persons as were best qualified to serve him with faithfulness and ability.' Before the crucial battle near Agra with Dara Shikoh, the last of the brothers, an astrologer had warned Aurangzeb not to sit on his elephant but to send a decoy. Sure enough, in battle the decoy was killed almost at once by a musket shot. An attendant propped him up and moved his arms to suggest that all was well.

After Dara Shikoh lost the battle he fled with his family to the west hoping to reach Persia, but was betrayed by a supposed ally. Many of his followers deserted him. Dara and his sons were captured and brought before Aurangzeb, and paraded through the streets dressed in rags and in chains.

Aurangzeb had his elder brother beheaded in August 1659. He then sent the head in a box disguised as a present to his distraught father in Agra. Dara's head was buried near his mother in the Taj Mahal; his body was displayed in Delhi, with many outpourings of public grief.

The Emperor Aurangzeb enthroned, opaque watercolour, Khemanand, c.1660. Johnson Album 2, 5

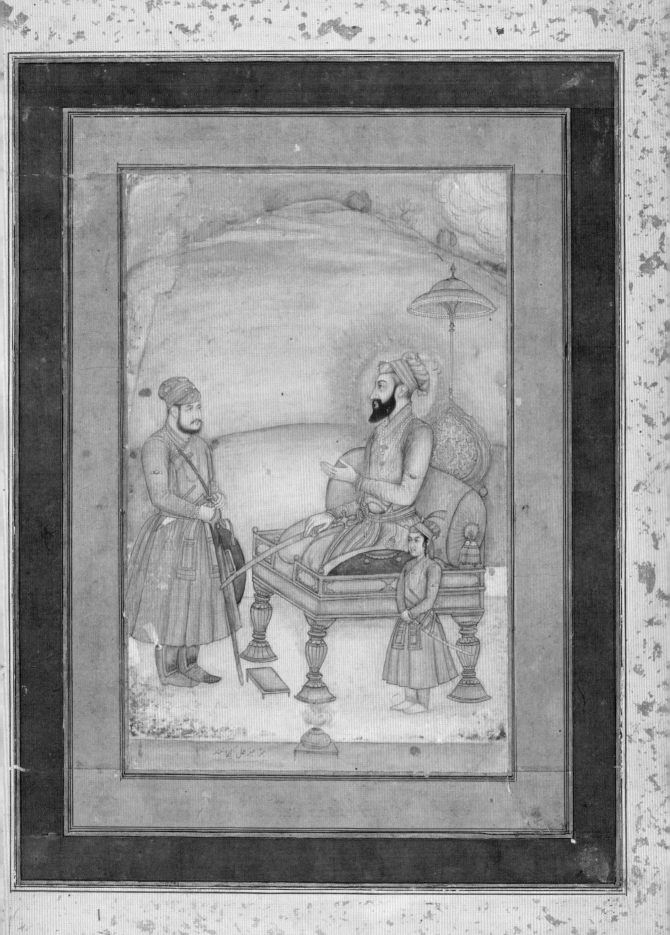

Aurangzeb and Greatness

'He is the truly great King who makes it the chief business of his life to govern his subjects with equity'.
Aurangzeb to his father

After locking him up at Agra Aurangzeb never saw his father again, but they corresponded bitterly. 'You did not love me,' he accused Shah Jahan. He reminded his father that he too killed members of his family who got in the way of his succession. More deviously, he claimed he was defending Islam against Dara's unorthodox beliefs, and the state against both anarchy and Shah Jahan's declining hold on power. What is perhaps rather surprising is how quickly everyone forgot their loyalty to both Shah Jahan and his intended heir. Tavernier (a French jeweller working in India) suggested that 'fear made them silent, and made them basely abandon a king who had governed them like a father'.

Aurangzeb was noted for keeping his cool – as battle raged around him he took out his prayer mat, and on another occasion had his elephant's legs chained together as a sign that he wasn't about to flee the field. Manucci observed that he 'was not used to displaying passion openly'. Nor did he present himself daily to his people like his forebears. Most striking was his critical reaction to the lavish court life of his predecessors. He was extremely austere in his own life: he dressed simply, didn't drink or take opium, or listen to music which he had once so enjoyed; nor was he a great patron of the arts. He made caps and sold them along with the produce of his farm and examples of his calligraphy to courtiers, and bought his clothes and food with the proceeds. He clamped down on excessive consumption of drink and drugs by others, and also on musicians and dancing women, elephant drivers and beggars. There were edicts against prostitution, eunuchs and *sati*, but it is not clear how effective any of these measures were.

Manucci observed: 'There can be no doubt that if any king ever had recourse to foresight to prevent disorder it was Aurangzeb', and rather optimistically claimed that nothing went on in Delhi without one of Aurangzeb's spies knowing about it. The emperor aimed to create a strictly moral Islamic state. He reintroduced the religious tax on non-Muslims and destroyed several Hindu shrines: estimates vary from 60,000 (a modern Hindu polemicist) to 15 (a modern historian). The ninth Sikh Guru was tortured and beheaded for refusing to convert to Islam. Aurangzeb's policies towards his non-Muslim subjects contributed significantly to the decline of Mughal power. He was not ruling equitably as emperor of all Indians, as Akbar had, and as Aurangzeb himself had declared as his intention.

Aurangzeb on horseback, *c.*1670. Johnson Album 3, 4

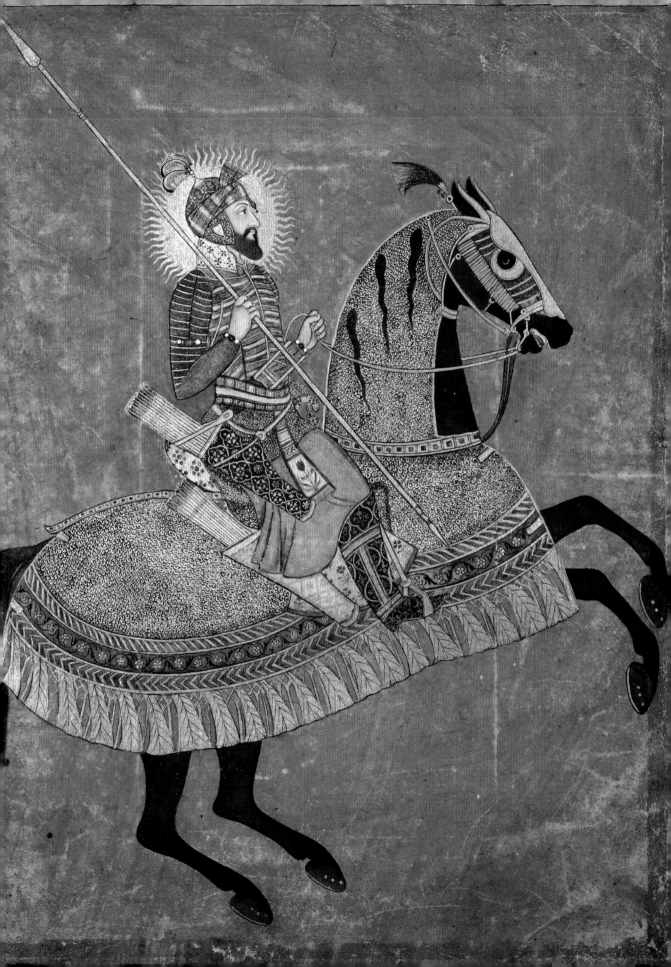

25 Aurangzeb on Campaign

' … there are sundry nations which the Mogul is not full master of, most of them still retaining their particular sovereigns and lords that neither obey him nor pay him tribute but from constraint'.
François Bernier

Equestrian portraits like this and the previous painting reflect the constant warfare of Aurangzeb's reign. Aurangzeb's foster-brother Khan Jahan Bahadur was successively Governor of Deccan, Allahabad and the Punjab. Aurangzeb dismissed him after he failed to win a crucial battle against the Marathas. Aurangzeb led his army on campaign right through his reign. He did not entrust this role to his sons, who in true Mughal fashion were either rebelling against their father or suspected of it. His eldest son was imprisoned for rebellion and died there; another died in exile in Persia, and a third always turned pale when receiving a letter from his father. One such letter of rebuke asked him 'what answer we shall give on the day of judgment' for 'withholding justice from the oppressed'.

Under Aurangzeb the Mughal empire was at its greatest extent: over a million square miles, with perhaps as many as 150 million subjects – this may have been a quarter of the world's population at that time. At the heart of apparent strength there were considerable weaknesses, including an uncertain succession. The expansion of the Mughal empire was a colossal strain on resources: on the army, the treasury, the economy, and on the emperor himself and his subjects. Aurangzeb began by pushing north to Ladakh, east to Bengal and then south – which proved much more intractable. Due to his rigidly Islamic policies, which were hostile towards Hindus, Aurangzeb lost the support of the Rajputs (of modern Rajasthan and further west) who had been the backbone of preceding Mughal regimes. He also stirred up the Marathas, fierce hill people along the western coast around Bombay, under their charismatic leader Shivaji. Having attacked the port of Surat in 1664 (to the alarm of the English merchants based there) Shivaji then refused submission to the emperor and continued his revolt. Despite a concerted campaign by Aurangzeb, Shivaji was able to leave behind a resilient belt of Hindu states across the Deccan by the time he died in 1680. Aurangzeb lamented: 'My armies have been employed against him for 19 years and nevertheless his state has always been increasing.'

He was more successful in Golconda, ending an epic eight-month siege of the massive fortification in 1687 and reaping a reward in diamonds from the famous Golconda mines. Aurangzeb spent the last decades of his reign fighting in the Deccan. As one historian commented, 'he suffered hardships that would have tried the constitution of a younger man'.

While Aurangzeb's heirs presided over the decline that followed, the Maratha Empire went from strength to strength.

Aurangzeb's foster-brother Khan Jahan Bahadur on horseback, *c.*1690. Hunhar, Johnson Album 18, 12

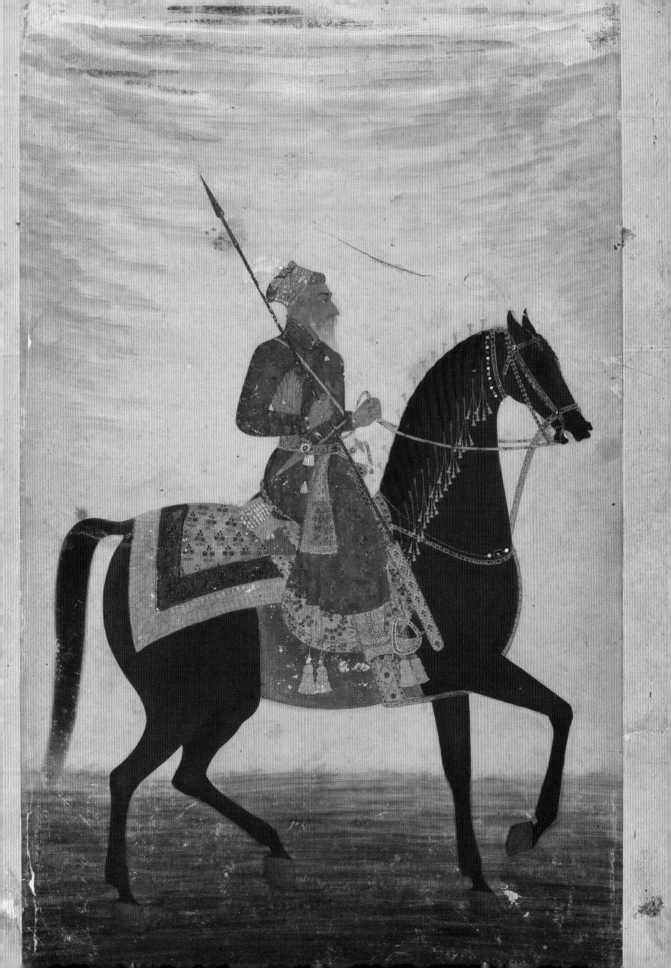

Aurangzeb's Death and Legacy

'Aurangzeb's life had been a vast failure, indeed, but he had failed grandly'.
Stanley Lane-Poole

'It is not perhaps fair to judge him by the rigid rules which we apply to the character of European princes'.
François Bernier

Despite a sickly childhood and a mysterious illness in 1662 that left his speech impaired, Aurangzeb was the great survivor. He was 89 when he died. Careri, a Neapolitan doctor, described him in 1695: 'He was of a low Stature with large Nose, Slender and stooping with Age. The whiteness of his round Bear'd was more visible on his Olive colour'd Skin.' He was still conducting business as usual, 'and by his cheerful, smiling Countenance seemed to be pleas'd with the employment'. Careri obviously picked a good day.

Aurangzeb appears piously self-critical at the end of his long life. In a letter written to his sons at the very end of his life he lamented:

'This weak old man, this shrunken, helpless creature, is afflicted with a hundred maladies besides anxiety, but he has made patience his habit.' 'I do not know who I am, where I am, where I am to go and what will happen to a sinful person like me. Many like me have passed away wasting their lives. Allah was in my heart but my blind eyes failed to see him. I do not know how I will be received in Allah's court. I do not have any hope for my future, I have committed many sins and do not know what punishments will be awarded to me in return.'

In his will he insisted that he should have no tomb but be buried in the forest, uncovered, so that '[I can] present myself to Allah with a naked face. I am told whoever goes to the supreme court with a naked face will have his sins forgiven.' 'No one should be permitted to place any flowers on my body. No music should be played or sung, I hate music.'

Unlike his immediate predecessors, Aurangzeb could not be confident about the ability of his heirs to maintain what he had spent his whole life establishing. No wonder then that his words were so bleak: 'Allah should not make anyone an emperor, the most unfortunate person is he who is an emperor ... No story of my life should be told to anyone.'

Profile portrait of Emperor Aurangzeb, opaque watercolour, *c.*1700. Johnson Album 2, 2

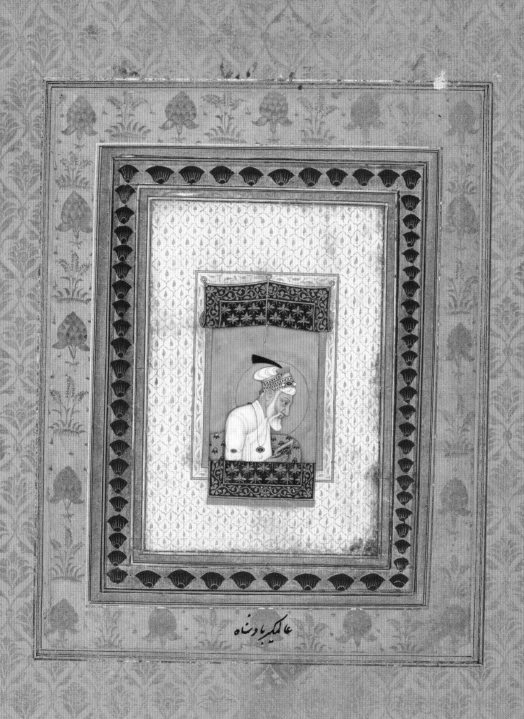

عالمگیر بادشاه

27 After Aurangzeb

Aurangzeb's son and heir Bahadur Shah I was already 63 when he became emperor, and he reigned just five years. Eight further emperors followed in quick succession over the next 50 years (some too briefly to be included in the official count). It proved difficult to re-establish a semblance of normal court life in Delhi, after 26 years in which Aurangzeb had usually held court in a tent. To maintain their inheritance Aurangzeb's heirs needed the political sense, willpower and energy of another Akbar. None of them remotely qualified – and the odds against them were anyway enormous.

The sadistic Mughal gene reasserted itself with a vengeance during the various ensuing power struggles. Bahadur Shah's eldest son Jahandar eliminated his brothers on the battlefield but then tried to execute their supporters as well, a new development in the empire. His debauchery and general incompetence as ruler encouraged his nephew Farrukhsiyar to rebel with the assistance of the new power behind the throne: the ambitious courtiers the Saiyid brothers. Jahandar was strangled in 1713 after a year's reign. When the puppet emperor Farukhsiyar showed signs of independence, the Saiyid brothers had him blinded and later strangled for trying to escape their clutches.

The Saiyid brothers created two other puppet emperors in 1719, but both were sickly and died almost immediately, before they hit on another grandson of Bahadur Shah, Muhammad Shah – 'a good-looking young man, with many good qualities and of excellent intelligence'. Muhammad Shah was not recognisable as a descendant of Aurangzeb: his nickname was 'colourful' and life for him was a round of partridge shoots and elephant fights, and visits to the harem. He is shown here, just a few years before disaster struck, with his vizier (chief minister) Qamar al-Din Khan. The artist took the name of the great seventeenth-century Mughal artist Govardhan.

After Aurangzeb's death the vultures began to gather around the promising carcass that was Mughal India: these included Europeans, India's neighbours and other rival rulers in India itself. States such as Hyderabad and Avadh, as well as Rajputs, Sikhs, Jats and Marathas, all continued to break away from the centre. In 1737 the Marathas raided the suburbs of Delhi. In March 1739 Delhi was sacked by the Persian ruler Nadir Shah. It was a disaster – the already badly tarnished prestige of the Mughals never recovered. In retribution for attacks on his soldiers Nadir Shah ordered his men to plunder Delhi. Thousands of Indians were killed: 'The streets remained strewn with corpses, as the walks of a garden with dead flowers and leaves. The town was reduced to ashes and had the appearance of a plain consumed with fire.'

The captured emperor Muhammad Shah had to beg for mercy and hand over his treasures. These included the fabulous gem-encrusted Peacock Throne created for Shah Jahan, the treasury, including the Koh-i-noor diamond, and much of the Royal Library. This raid was so successful that Nadir Shah stopped all taxes in Persia for three years.

Muhammad Shah and vizier, c.1735. Govardhan II, Johnson Album 38, f.7b

محكوم اوچرخ برين يادبدادم تا بنده ستاره ثين حسين يادبدادم
ماننده خورشيدالهى اورا عالم همه فروريكين يادبدادم

28 The Arts after Aurangzeb

Although there were few Mughal architectural projects after Aurangzeb, whose great buildings include the tomb of his wife at Aurangabad and the Royal Mosque in Lahore, painting did continue to flourish though not necessarily at the imperial court. This serene image from Muhammad Shah's reign gives a glimpse of art and life as seen by one of the emperor's remaining great artists. Against a beautifully depicted night sky, alive with stars, some kind of ceremony is taking place on a terrace with typical marble pavilions and a small fountain. The artist has lavished great care on the clothes of the participants, most of whom hold gifts. The mullah and his assistant at the centre hold lights, and the focus of this event would appear to be the young boy. It is suggested that he is being initiated into a religious order.

The painter of this picture, Govardhan, should not be confused with the great artist of the same name who worked for Jahangir and Shah Jahan; adopting the names of earlier artists was quite common. The days of a large court workshop of artists were long past, declining particularly under Aurangzeb. So artists found work at other courts, in Rajasthan – Bikaner, Kishangarh, Jodhpur – and in the Muslim courts such as Lucknow (Avadh) and Murshidabad (Bengal). Eighteenth-century Mughal rulers no longer had the resources or the will for major building projects, but other Indian rulers did. A notable example is the planned city of Jaipur in Rajasthan, created from 1725 on a grid-plan by Maharaja Jai Singh, a remarkable man who is famed also for his astronomical observatories there and in Delhi. While at court he had persuaded Muhammad Shah in 1720 to abolish the jizya tax, re-imposed on the Hindu population by Aurangzeb.

A major monument from this period in Delhi is the tomb of Safdar Jang, a Persian who served in the imperial army, who became Governor of Avadh and was enormously rich and powerful. His tomb, built in 1753–4 and based on Humayun's tomb, is probably the last significant Mughal building. Safdar Jang illustrates the decline of Mughal power after Aurangzeb. He was in effect an independent ruler, and made himself vizier (chief minister) at the Delhi court during the reign of Muhammad Shah's son Ahmad Shah (1748–54). He was eventually forced out of Delhi, but was later buried there in the tomb that (like Humayun's) stood in splendid isolation outside the city.

A ceremony by night on a terrace, c.1730. Govardhan II, Johnson Album 1, 28

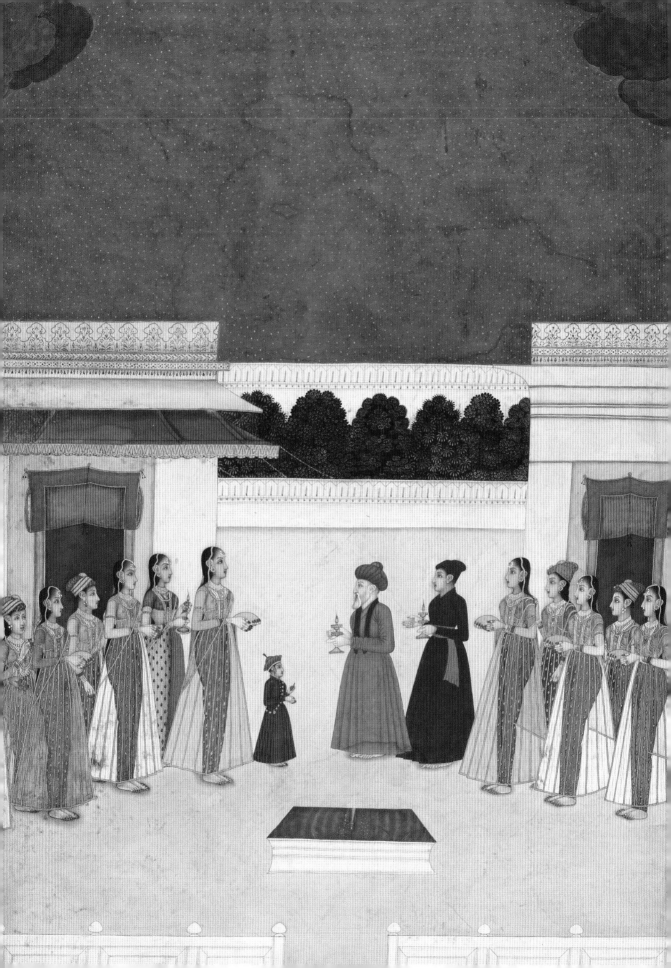

29 The Battle of Panipat

'… anarchy has arisen, and everyone proclaims himself a sovereign in his own place
… the strong prevailing over the weak… In this age of delusion and deceit His
Majesty places no dependence on the service or professions of loyalty of anyone but
the English chiefs'
Letter from Emperor Shah Alam to the East India Company, 1768

The Mughal emperor was by now largely at the mercy of rival powers in India. The
battle shown in this painting was fought between two of them in 1761 at Panipat
(scene of Babur's great victory against the Lodis in 1526). This battle was waged
between Hindu Marathas (depicted on the left in front of the town) and Muslim
Afghans under the leadership of Ahmad Shah Abdali (picked out in colour opposite).
An army of 45,000–60,000 Marathas, under Sadashivrao Bhau, with artillery supplied
by the French, were pitted against the heavy cavalry and mounted artillery of the
Afghans and their Indian allies including the Navab of Avadh, Shuja al-Daula, and
Najib Khan, the leader of the Afghan Rohillas. The battle lasted for several days and
involved over 125,000 troops; there were a colossal number of casualties, perhaps as
many as 60,000 dead. According to one eyewitness, thousands of Maratha prisoners
were slaughtered in cold blood the day after the battle. 'The unhappy prisoners were
paraded in long lines, given a little parched grain and a drink of water, and beheaded
… and the women and children who survived were driven off as slaves – twenty-two
thousand, many of them of the highest rank in the land.'

The Marathas never fully recovered from their defeat at Panipat, but once the Afghans
had departed the Marathas did retake Delhi. The city's troubles were not over, however:
Rohilla Afghans raided Delhi again in 1788 under the sadistic Ghulam Qadir ('Scourge
of God'). Furious that there was so little left to loot, he blinded the Emperor Shah Alam
and other princes, made them dance before him and abused the royal women, taking
some of them into his harem. The Marathas arrived too late to save them.

'How can I describe the desolation?' asked the poet Sauda. 'There is no house from
which the jackal's cry cannot be heard. The mosques at evening are unlit and deserted.
In the once beautiful gardens, the grass grows waist-high around fallen pillars and the
ruined arches.'

There was slight retribution a few months later, when Ghulam was himself captured
and dismembered. His eyeballs, nose and ears were delivered to Shah Alam, the
emperor he had blinded. Shah Alam had reduced the army to 5,000 men as part of
his reform. He was therefore unable to withstand either marauding Afghans or rival
Indian states – nor the growing power of the British. The fortunes of the British East
India Company had been transformed after Robert Clive's victory at the Battle of
Plassey in 1757. In the new balance of power Mughal emperors would be increasingly
under British influence – and then under their control.

The Battle of Panipat (1761), c.1770. J66, 3

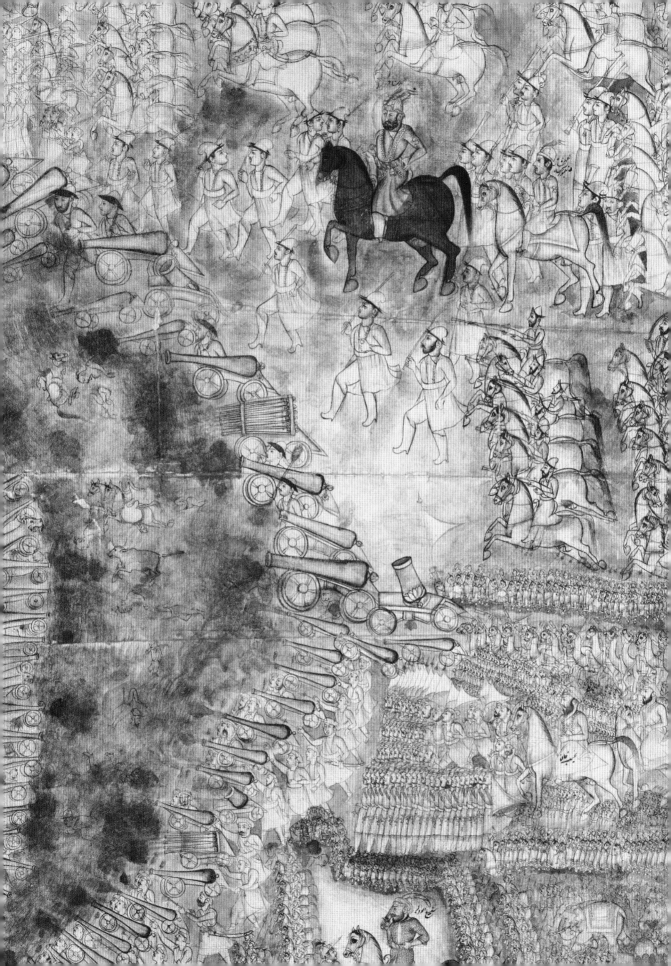

Warren Hastings was the first Governor-General of Bengal, from 1773 to 1785. That title alone suggests the erosion of Mughal sovereignty and the ambitions of key players in the East India Company, which had now outgrown its somewhat shaky seventeenth-century origins as one of several foreign trading posts in India and had become the dominant European force there. Starting out in 1750 as a humble clerk in Calcutta (the Company's headquarters) Hastings worked his way up, learning Urdu and Persian, and demonstrating his abilities. He also benefited from an era of disruption. His early years in India were dramatic ones, when the future of the British in India was at stake. Having himself been imprisoned by the hostile Siraj al-Daula, Navab of Bengal, he joined the army of Robert Clive, which relieved Calcutta in 1757. This followed the notorious incident of the so-called 'Black Hole of Calcutta', when a disputed number of British prisoners died in captivity. Clive noticed Hastings and helped further his career. After Clive's victory over the Navab at Plassey in 1757, and only eight years after arriving in India, Hastings was made the British Resident (ambassador) in the Navab of Bengal's capital, Murshidabad.

Hastings was interested in Indian culture, and encouraged historical research and translations of Indian texts. He was also sympathetic to the situation of Indian rulers, while under pressure himself to defend British interests in a context where traditional authority was crumbling, notably in Delhi. The Navab of Bengal theoretically owed allegiance and tribute to the Mughal emperor; that stopped after Plassey. Now the East India Company levied taxes itself, even during times of widespread famine. As the Company was drawn more and more into Indian politics so the British parliament tried to take greater control over the Company. Hastings was promoted to be the first Governor-General and tried to maintain a balancing act between Company demands and local power structures and traditions, but had to go to war with the Marathas following the breakdown of relations between them and the British, and had to find ways to fund the costs of that war. On his return to England after 1784 he was made the symbolic scapegoat for the Company's excesses, although he was eventually exonerated. His successors as Governor-General further tightened the screws in exacting taxation and eliminating rival Indian powers, notably Tipu Sultan of Mysore, the Marathas and the Sikhs.

In 1803 after defeating the Marathas just outside Delhi, the British general Lord Lake met the puppet emperor, Shah Alam, now aged 75 (*see* 29). His first encounter was a shock: 'The descendant of the great Akbar and Awrangzeb was found blinded and aged, stripped of authority and reduced to poverty, seated under a small tattered canopy, the fragment of royal state and the mockery of human pride.'

Shah Alam's heirs would be merely figureheads – captive emperors of just the Red Fort and a small area of Delhi.

Portrait of Warren Hastings by a Lucknow artist, *c*.1782. Or 6633, f.67a

31 Akbar Shah and His Sons

'… exalted emperor of angelic hosts, prince Shadow of God, refuge of Islam, propagator of the Muhammadan religion, progeny of the House of Timur, most magnificent sovereign emperor, sovereign son of sovereign, sultan son of sultan, lord of glories and victories, true dispenser of good things, metaphorical lord …'

So ran the inscription of another portrait of Akbar Shah II, shown here with his sons. He was the son and heir of the blinded Shah Alam who had died in 1806, three years after Lord Lake's first encounter with him. Akbar Shah was the last but one Mughal emperor. The son who would be last emperor of all is seated on the right nearest to his father. Akbar Shah had been one of the princes humiliated by Ghulam Qadir in 1788, and forced to dance before him. The humiliation continued under the British – from the British takeover in 1803 he was referred to by them as the 'King of Delhi' (rather than Emperor), although even that title was an exaggeration. He had limited uses even as a figurehead, or so the British thought. The fiction that the East India Company ruled at his behest was gradually abandoned, and the Company issued their own coins in English rather than under his name from 1835. The British had earlier made themselves at home in India, wearing Mughal dress, patronising Mughal artists and taking local wives and mistresses. A new generation of British officials, however, was replacing these 'white mughals' and was no longer content with the pretence of ruling through the Emperor. 'I have renounced my former allegiance to the house of Timur,' announced Sir Charles Metcalfe in 1832, the earlier British Resident who had done most to define the relationship between the British and the Emperor.

Appropriately, the artist has captured here a sense of foreboding and gloom, unrelieved by the blue sky imagined behind. Gone is the jewelled splendour of the imperial durbars seen in earlier illustrations, and gone also any pretence to the titles quoted earlier. While not quite as desolate as the scene described by Lake in 1803 (quoted in the previous entry), it is still a depressingly sombre and rather awkward image, where the artist does little to salvage the situation. Ghulam Murtaza Khan was the main court painter and belonged to a family of artists – another member described himself as 'the hereditary slave of the dynasty, Ghulam Ali Khan the portraitist, resident at Shahjahanabad'. To make a living the family worked for British clients and other Indian rulers. Not surprisingly, many leading artists had long ago deserted the shrunken and impoverished Mughal court to work for other masters, for example in Rajasthan and Lucknow. A new kind of art did, however, develop in a Delhi that was now only part Mughal. This can be seen in portraits, miniature paintings made especially for new British patrons, and panoramas such as those on the following pages.

Akbar Shah II and four of his sons, c.1812. Ghulam Murtaza Khan, Add.Or.342

The Red Fort in 1846

'Whoever enters this gloomy palace, / Remains a prisoner for life in
European captivity'.
Bahadur Shah II

This image gives only a hint of the Red Fort in Delhi at its most splendid. Visiting it
today after its partial destruction by the British after 1858 it is difficult to appreciate
the Persian inscription: 'If there be a paradise on the earth, it is this, it is this, it is
this!' Yet it had been the centre of the Mughal empire at its zenith and then for the
century-and-a-half of decline. The Red Fort, Shah Jahan's red-walled palace, covered
an area twice that of the Escorial outside Madrid and included numerous bazaars and
workshops. It was laid out on a strict grid and from the top of the Lahore or western
gate we can see the successive courtyards that approached the inner sanctums of
the Divan-i Khas (private throne pavillion) and the Rangmahal or zenana (women's
quarters). The jumble of buildings seen from this viewpoint include the quarters of
the Salatin, the 2,000 or so minor royals often living in some poverty behind the high
enclosing wall, separated from the immediate royal family.

Today, some of the most important white marble pavilions survive in isolation.
A water-course, the 'stream of paradise', originally ran through all the pavilions
including the Divan-i Khas.

This panorama was commissioned by Sir Thomas Metcalfe (1795–1853), the
Governor-General's agent at the imperial court. Three years before the panorama
was completed for him by Mazhar 'Ali Khan, Metcalfe had compiled his album of
'Reminiscences of Imperial Delhi' with over 100 paintings of views of Mughal and
earlier monuments. Following the Persian raids of 1739, the Peacock throne is no
longer to be seen here, but the public throne pavilion, the Divan-i Am, still has the
Italian panels depicting Orpheus playing his lute to the animals. The zenana (women's
quarters) survive, as does the Pearl Mosque created for Aurangzeb. The 'Life-
Bestowing Paradise Garden'– which once featured apricots, mangoes, cypresses and
many scented plants – has a pavilion added by the last emperor, Bahadur Shah II. The
other residential palaces were destroyed by the British after the events of 1857. The
Red Fort became an army barracks, and an officer's mess was installed in the Divan-i
Khas. In 1858 the British blew up most of the area between the Red Fort and the Jama
Masjid. This panorama is therefore a record of a vanished world.

A section from a panoramic scroll of the city of Delhi viewed from the Lahore Gates of the
Red Fort, Mazhar 'Ali Khan, 1846. Add.Or.4126

Overleaf: Four sections from a panorama showing the procession of the Emperor Bahadur Shah II
to celebrate the feast of Id, 1843. The Emperor is depicted in a howdah on an elephant, followed
by two other elephants with empty howdahs and then the heir-apparent. Add.Or.5475, f. 59v-D

The Emperor

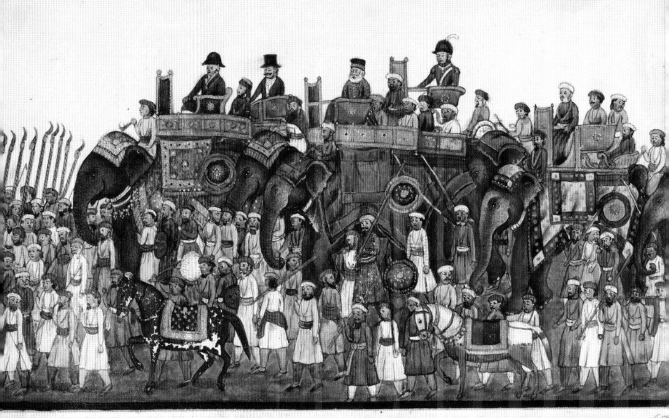

The Resident Assistant & Commandant
of Escort

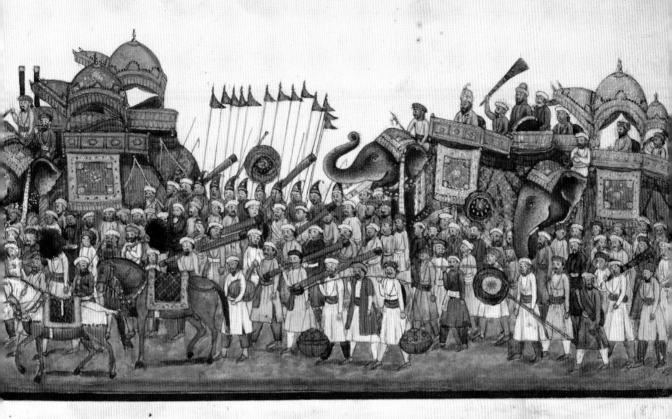

3 Heir Apparent. Sons & Relatives

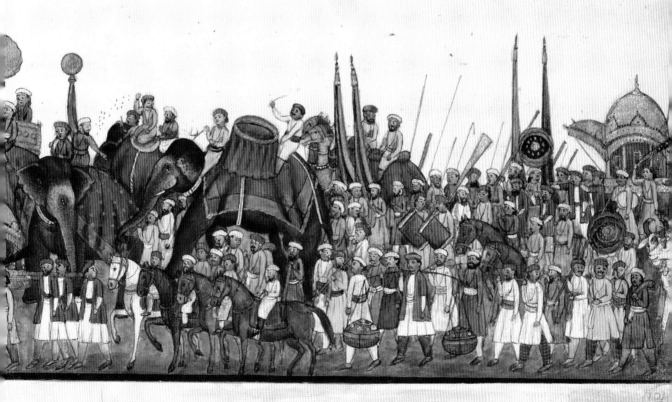

33 The Last Mughal Emperor

'I want to shatter the bars of my cage / With the fluttering of my wings
But like a caged bird in a painting / There is no possibility of being free'
Bahadur Shah II

The last Mughal emperor, Bahadur Shah II (1837–58), known also by his poetic name
of Zafar, had only symbolic power, and even that was to be his downfall. The British
had already decided that the Mughal dynasty was going to end with him, even if
the events of 1857 had not unfolded as they did. Bahadur Shah's British minder, Sir
Thomas Metcalfe, was ordered to remove the Mughals from the Red Fort once the
aged emperor died. So dispirited did Bahadur Shah become by his treatment that at
one point he sought to abdicate and go on pilgrimage to Mecca. Metcalfe's private
opinion of Bahadur Shah was that he was 'mild and talented but lamentably weak
and vacillating and impressed with very erroneous notions of his own importance,
productive of great mortification to himself and occasionally of much trouble to the
local authorities.'

We have already seen Bahadur Shah in a portrait with his father Akbar Shah (*see* 31).
Like his father, Bahadur Shah had experienced the humiliation of his family in
1788 at the hands of Ghulam Qadir, who blinded his grandfather. Under Bahadur
Shah, Mughal culture flowered one last time. Like the best of his ancestors, he was
tolerant, highly cultivated, an accomplished poet writing in several languages, a skilled
calligrapher; a patron of rival poets and families of painters. He inherited the Mughal
passion for gardening and closely supervised the last of the Mughal gardens in the Red
Fort. He delighted in simple pleasures: watching his elephants being washed, or flying
kites, at which he was highly skilled and drew admiring crowds. He was more or
less under house arrest, and his authority extended only to attempting to control the
behaviour of his servants and family and the correct performance at ceremonies. He
had no battles to fight and no country to govern.

Bahadur Shah was already in his mid-60s when, as Metcalfe put it, he 'ascended to the
fallen Dignity of the once mighty House of Timour'. But those remnants of imperial
dignity were enough to attract the mutinous Indian troops in Delhi and northern India
in May 1857. They erupted without ceremony into the private quarters of the Red
Fort. Bahadur Shah told them: 'I did not call for you; you have acted very wickedly.'
They asked for his blessing and he, powerless, reluctantly gave it. The mutinous troops
wanted the Mughal Empire to be fully restored; daily durbars were to be held for
the first time since 1739 – there were even fireworks. But as Bahadur Shah himself
observed, 'the name of the great Timurid emperors is still alive, but soon that name
will be completely destroyed and forgotten'. The British were now being massacred
throughout Delhi; looting and chaos ensued. The uprising escalated rapidly across
northern India. There was no going back. Bahadur Shah was now the prisoner of new
masters.

Bahadur Shah II, Metcalfe 'Reminiscences', 1844. Add.Or.5475, f.16v

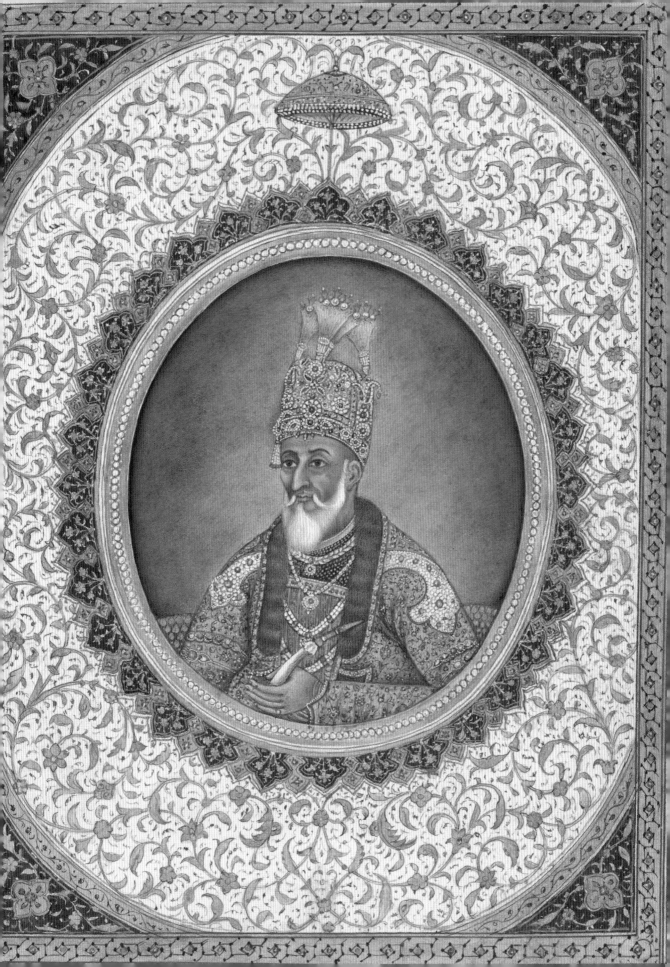

34 The End of a Dynasty

'The sun of our life has already reached its evening. These are our last days.
All I wish for is retreat and seclusion'.
Bahadur Shah II to the rebels, May 1857

British troops from other parts of India converged on Delhi and their siege lasted from June to September 1857. Bahadur Shah watched the bombardment from the ramparts of the Red Fort. Then in September, amid brutal street fighting, the British took control of the city. As one of them recorded later: 'All the city's people found within the walls of the city of Delhi when our troops entered were bayoneted on the spot, and the number was considerable, as you may suppose, when I tell you that in some houses forty and fifty people were hiding. These were not mutineers but residents of the city, who trusted to our well-known mild rule for pardon. I am glad to say they were disappointed …' Zafar's former court poet, Ghalib, was a rare survivor: 'One must have a heart of steel to witness the contemporary scene … helpless I watch the wives and children of aristocrats literally begging from door to door …'

By the time the British reached the Red Fort, Bahadur Shah had already fled with some of his family and gone into hiding at Humayun's tomb, on the outskirts of Delhi. British soldiers arrived at the tomb, and guaranteed his safety, and so he surrendered on 20 September 1857. He was brought back into Delhi on a farmer's cart. Two of his sons and a grandson were shot without trial, and other executions followed. The remaining royals were distributed around prisons in India, the Andaman Islands and Burma. Bahadur Shah was kept for a year in increasingly squalid quarters in his wrecked palace, where he was taunted by British visitors like a caged animal. It's a mystery how anyone could have believed that this frail old man was capable of masterminding anything, as was claimed at his trial. Bahadur Shah was put on trial for rebellion, treason and murder: this photograph shows him aged 82 awaiting trial. After a 40-day trial he was sentenced to be exiled to Burma with his wife, Zinat Mahal, two sons and a small household. He died in Rangoon on 7 November 1862 and was buried near the Shwedagon Pagoda in an anonymous grave.

Bahadur Shah had embodied the highly cultivated side of the Mughals, as poet-calligrapher and lover of gardens, but had been cruelly thrust into a situation over which he had no control. With him died a remarkable dynasty that had flourished under six emperors, but had then collapsed under the impossible weight of its responsibilities.

Photograph of Bahadur Shah II taken by Robert Tytler and Charles Shepherd, 1858. Photo 797/37

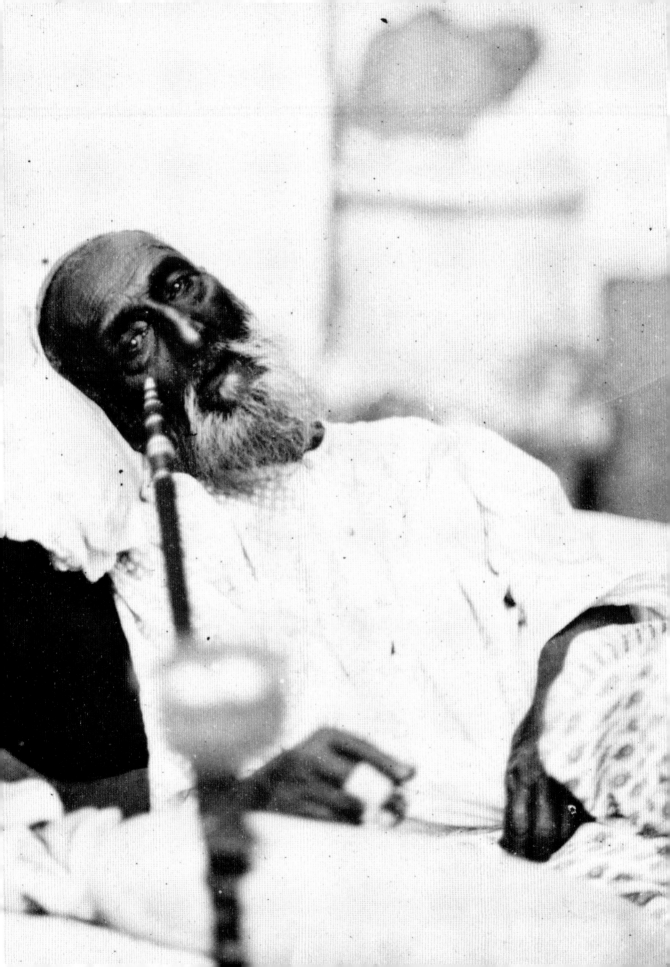

35 Epilogue

1858 was a turning point. The Mughal dynasty ceased to exist. The East India Company was dissolved, and British India was now controlled by direct rule from Westminster. This was to last for less than a century, after three centuries of Mughal rule. The British viceroy ruled first from Calcutta and then only much later from New Delhi. In the meantime, Old Delhi licked its wounds – wounds which are revealed in photographs of the city after the siege and devastation, by Felice Beato and others. As Bahadur Shah himself wrote:

> Delhi was once a paradise,
> Where love held sway and reigned;
> But its charm lies ravished now
> And only ruins remain.

Surviving members of the Mughal dynasty were soon dispersed. In Burma, Bahadur Shah's queen Zinat Mahal died in 1882, and one of his sons soon afterwards. The descendants of the other son still live in Rangoon. In Delhi in the late 1980s the historian William Dalrymple met an aged princess who was the granddaughter of another of Bahadur Shah's sons. One of Bahadur Shah's brothers fled Delhi in 1857 and ended up in Bengal, and his descendants still live in Bangladesh. Other descendants have been traced to Calcutta, Hyderabad and Aurangabad; there are more in the USA, Canada and the Middle East.

The Cashmere Gate, Delhi, *c.*1858. Felice Beato, Photo 25/(14)

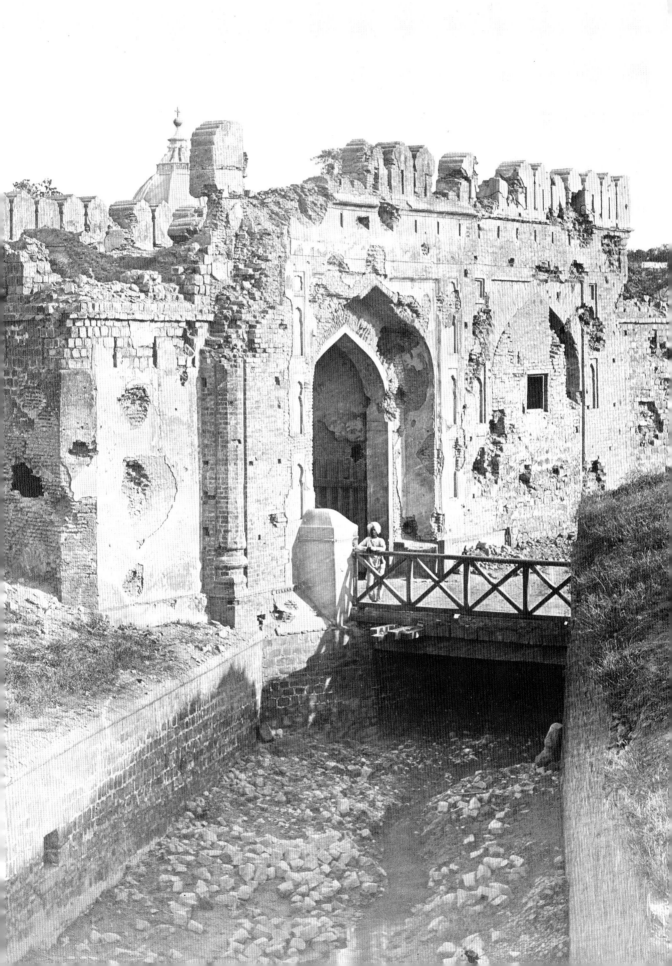

Bibliography

Crill, R. and Jariwala, K., *The Indian Portrait: 1560–1860*,
National Portrait Gallery, 2010.

Dalrymple, W. and Sharma, Y., *Princes and Painters in Mughal Delhi, 1707–1857*,
Yale University Press/Asia Society, 2012.

Dalrymple, W., *The Last Mughal: The Fall of a Dynasty, Delhi, 1857*,
Bloomsbury, 2006.

Dalrymple, W., *City of Djinns*, Harper Collins, 1993.

Eraly, A., *The Mughal Throne*, Weidenfeld and Nicolson, 2003.

Falk, T. and Archer, M., *Indian Miniatures in the India Office Library*,
Sotheby Parke Bernet, 1981.

Fisher, M., *Visions of Mughal India: An Anthology of European Travel Writing*.
I.B.Tauris, 2007.

Gascoigne B., *The Great Moghuls*,
Constable and Robinson, revised editions 1998 and 2002.

Guy, J. and Swallow, D. (eds) *Arts of India 1550–1900*, V&A, 1990.

Keay, J., *India, A History*, Harper Collins/ Grove Press, revised and expanded edition,
2010.

Keay, J., *The Honourable Company: A History of the English East India Company*,
Harper Collins, 1991.

Keene, M. with Kaoukji, S., *Treasury of the World: Jewelled Arts of India
in the Age of the Mughals*, Thames & Hudson, 2001.

Koch, E., *The Complete Taj Mahal and the Riverfront Gardens of Agra*, Thames & Hudson, 2006.

Losty, J.P., *Indian Book Painting*, British Library, 1986.

Losty, J. P., *Art of the Book in India*, British Library, 1982.

Losty, J. P. and Roy, M., *Mughal India: Art, Culture and Empire*, British Library, 2012.

Richards, J. F., 'The Mughal Empire' in *New Cambridge History of India*, Cambridge University Press, 1993.

Robinson, F., *The Mughal Emperors*, Thames & Hudson 2007.

Rogers, J. M., *Mughal Miniatures*, British Museum Press, 1993.

Schimmel, A., *The Empire of the Great Mughals: History, Art and Culture*, Reaktion Books, 2006.

Stronge, S., *Made for Mughal Emperors: Royal Treasures from Hindustan*, I.B.Tauris, 2010.

Stronge, S., *Painting for the Mughal Emperor: The Art of the Book, 1560–1660*, V&A, 2002.

Eraly, Gascoigne, Keay (2010) and Robinson all have useful lists of original sources. Many of these, such as the Baburnama and European travellers' accounts, can be read online.

Acknowledgments
Thanks to Jenny Lawson and David Way of the British Library for all
their help, and to Cathy Rostas for all her encouragement and her critical
reading of draft texts.

Map on page 4: ML Design after lrfan Habib, 1982
First published in 2012 by
The British Library
96 Euston Road
London NW1 2DB

British Library Cataloguing in Publication Data
A catalogue record for this publication is available from the British Library

ISBN 978 0 7123 5887 3

Designed and typeset by Kate Bates, British Library Design Office
Printed in Hong Kong by Great Wall Printing Co. Ltd

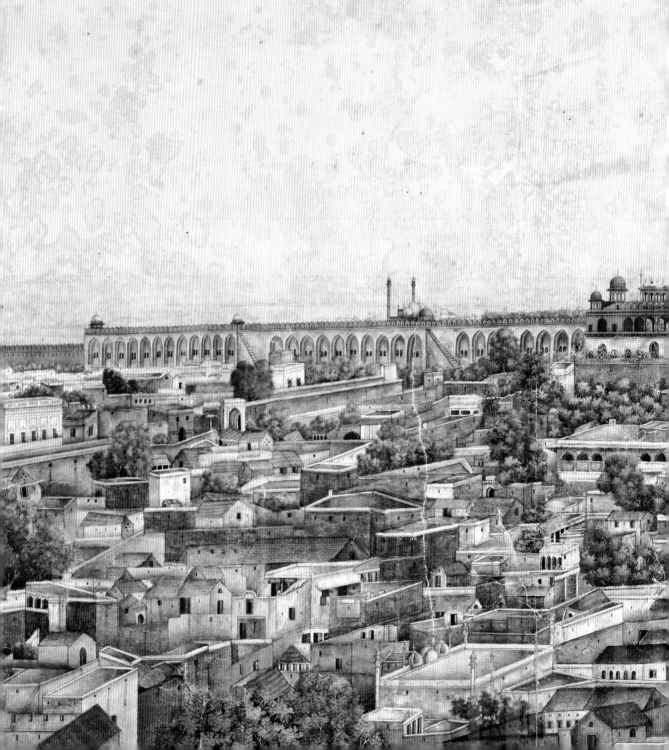

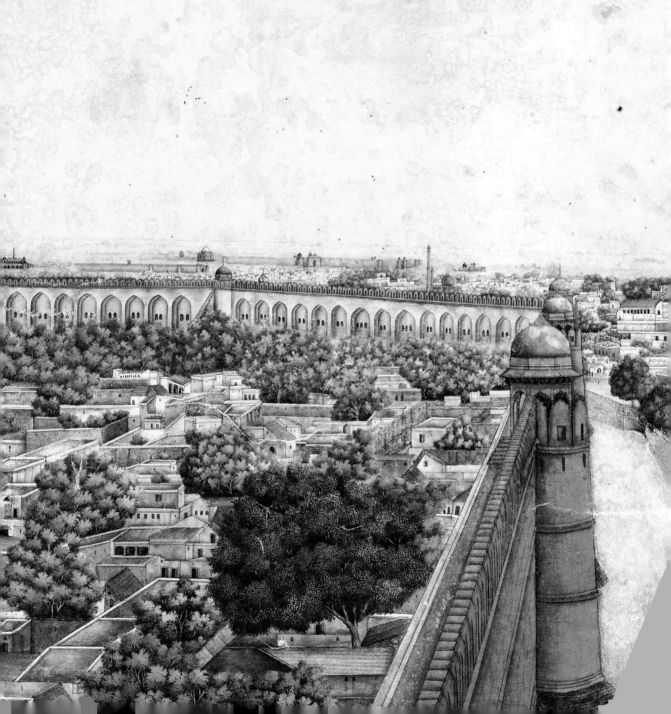